Living and Sustaining a Creative Life

Living and Sustaining a Creative Life

essays by 40 working artists

Edited by Sharon Louden

intellect Bristol, UK / Chicago, USA

This book is dedicated to my
loving husband, Vinson Valega

First published in the UK in 2013 by
Intellect, The Mill, Parnall Road, Fishponds, Bristol, BS16 3JG, UK

First published in the USA in 2013 by
Intellect, The University of Chicago Press, 1427 E. 60th Street,
Chicago, IL 60637, USA

A catalogue record for this book is available from the
British Library.

Cover image: George Stoll
Untitled (15 tumblers on a 36 inch shelf #3)
Beeswax, paraffin and pigment on a painted wooden shelf
$8^{3/4}$" x 36" x 7"
2012
Courtesy of the artist
photo by Ed Glendinning

Cover designer and typesetting: Holly Rose
Copy-editor: Michael Eckhardt

ISBN 978-1-78320-012-2
ePDF 978-1-78320-136-5
ePub 978-1-78320-135-8

Printed and bound by Gomer, Ceredigion.

CONTENTS

CONCLUSION

ACKNOWLEDGMENTS

PREFACE

IN 1991, I graduated with an MFA from Yale University, School of Art, and was struggling to live with a mountain of debt from school loans and credit card bills. I had taken a job as an administrative assistant that did not pay enough to make ends meet, and I was having difficulty striking a balance between making my work and paying the bills. Then living in Williamsburg, Brooklyn, I remember calling one of my former professors and asking him what to do. His response was, "Just do your work and it will carry you." While I knew my work was the priority in my life, the conversation left me at a loss. How was I going to sustain a creative practice while trying to survive?

Leaving graduate school, I also faced your typical expectations, desires and question marks. And I harbored certain illusions. For instance, I thought that a gallery was going to support me financially and emotionally, and that I didn't have to work for very long at other jobs before such a relationship was established. I expected that the feeling of Utopia which flowed from the fluid exchange and sharing of ideas among my fellow students at graduate school would continue once I graduated. I also hoped to create dialogue with the local art community as I explored alternative ways to get my work seen. Over the years, I've had to find my own path, and I only wish that I had had artists to lean on and consult such as the contributors to this book.

The premise of this collection of essays is to show the reality of how artists – from the unknown to the established – juggle their creative lives with the everyday needs of making a living. I believe that this subject has been neglected and pushed to the margins of art discourse throughout history, almost as if it were a source of embarrassment. Making art and participating in the art world over a lifetime is a challenge enough, and those who have navigated it can certainly learn from one another.

The details in the following essays seem to me invaluable for many reasons, but among the more important are: (1) they show how artists turn obstacles into inspiration, both inside and outside of their studios; (2) they explain to people who may not be fully aware why money is not the only measure of artistic success; (3) they attack the old myth of the "poor, struggling artist" for whom great pain is a requisite for great art; and (4) they address the delicate questions of educational debt and community support in a culture that normalizes and encourages competition.

Through these artists' words, we hear both general approaches to the conundrum of sustaining the creative life, and also specific solutions to navigating individual circumstances. Each essay is a particular story. For instance, we hear from Michelle Grabner about her efforts to sustain her creative life while juggling three full-time jobs: Chair of the Painting and Drawing Department of the School of the Art Institute of Chicago; mother of three children; and co-founder, along with her husband, of two artist-run exhibition spaces – The Suburban and The Poor Farm. Brian Novatny inspires with his continued commitment to his work in Bushwick, Brooklyn, holding down various odd jobs while making work for two to three shows a year, both in the US and in Germany. Having broken his "cycle of repetition" brought on by years of having to satisfy the demand of gallery exhibitions, he now embraces the liberating paycheck that comes from working as an art handler. Tim Nolan, from Los Angeles, traces his everyday life under various headings and categories: Relationships, Research, Seeking Out, Public Relations, Keeping Current, Professional Commitments, Side Job, and Studio Work. It's a fascinating map of an inspiring, long career that has now also begun to move into the public art realm. Will Cotton, an artist able to support himself from sales of his work, reminds us

once again that money has little to do with sustaining a creative life, and can even get in the way. He recalls his early days in New York, when, out of necessity, he taught himself contractor skills to make ends meet. Beth Lipman, the mother of two young children, married to her studio and business manager, describes in her concise essay what life is like for an artist living on a farm in Wisconsin. She reveals the feeling of "leaping off a cliff" when she quit her full-time, salaried position (with benefits) into the unknown world of the full-time studio artist.

It's the truth of the day-to-day living that I am after in this book, since these details help rectify the many misperceptions that still exist in the art community, the most common of which is addressed by the gallerist Ed Winkleman in our conversation at the end of the book:

> I think whether or not you have a gallery is a question a lot of people who identify as an artist are asked almost immediately. And within the population at large of people who kind of understand how the art world works, it is seen as a milestone. Seen as a potential career goal. But I also find that there *are* younger artists using the model of building an art career completely independent of a commercial art gallery system, and it is equally viable. I think it doesn't get as much attention because there aren't consistent advertising or promotional pushes for those artists. As opposed to a gallery artist who gets more exposure through the promotion of a gallery.

The idea that one needs a gallery to justify one's existence as an artist is, I believe, outdated: the gallery is just one venue through which to share a visual vocabulary with others. What's most important is that an artist is an artist no matter if he or she holds down another job, chooses to follow an untraditional path, remains relatively obscure throughout life, or is represented by a gallery. The power of creativity does not just lie in an artist's work, but also in how he or she continues to create regardless of the obstacles life places in the way. The process of simply making work over time should be celebrated, since our society so often judges artists externally by false milestones.

I began developing the idea of this book by coming up with a list of 40 artists who I knew could speak candidly about their lives

in a very personal way. I chose them because I felt comfortable going back and forth with them, asking questions and drawing out intimate features of their lives. Several generations are represented in these pages, and also various geographies. About half of the contributors reside in New York City, and the other half in different parts of the United States. Two live and work in Europe. The common thread is the great respect I have for all – the work they make and how they live. All of these artists thrive in their practice. They are serious and dedicated, deeply engaged and committed. These stories of how they sustain creative lives, often with struggle, are immeasurably inspiring.

The book begins with a quote from Carter Foster, Curator at the Whitney Museum of American Art, which sets the tone for the essays that follow. When I first met Foster, one of the many things that impressed me about him was his belief that external validation was never a prerequisite for the success of an artist, and I am honored by his contribution to this project.

Two interviews appear along with the 40 essays. It was important for me to include Thomas Kilpper and Will Cotton, but each was unable to write essays. The interview with Kilpper was via e-mail, and the one with Cotton was recorded in person at his studio in New York.

I feel sure that the essays collected here will provide many useful ideas, lots of different pathways and a tremendous amount of inspiration, not only for art students and those wishing to make a living as an artist, but also for others curious to learn how an artist in the twenty-first century navigates it all.

Sharon Louden

INTRODUCTION

FOR ME, ARTISTS are driven to do what they do no matter what. It's a very powerful ambition and they pursue it in whatever way works best for them. Artists have a practice and pursuing and developing it is always the motivating factor, not whether or not they will sell something or even find a venue in which it can be seen. In my experience, artists are among the most self-motivated, organized, the most disciplined, and the hardest working people I know. Sure, some artists are lucky enough that they can make a living doing it while other artists work day jobs or supplement their practice by teaching or other means. But I don't think the distinction is important. It's the seriousness of purpose that I admire the most.

Carter E. Foster
Curator, Whitney Museum of American Art

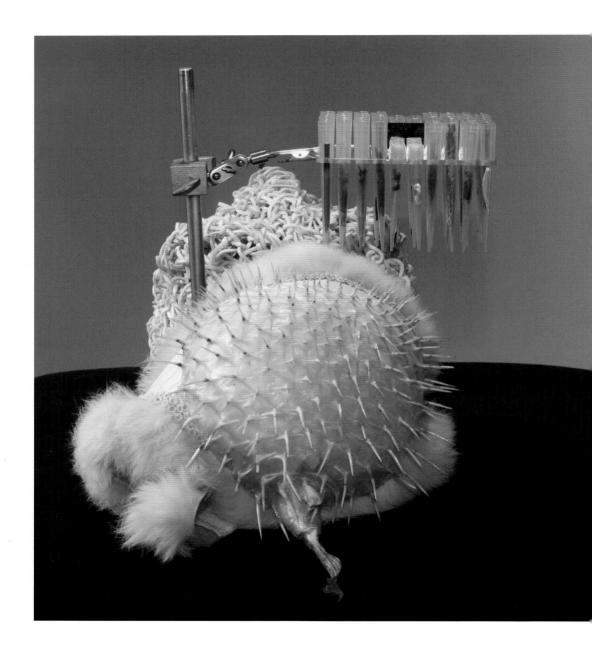

Adrienne Outlaw
How to Mistake Your ___
for a ___ (detail)
56"x50"x18"
People, wood, human, animal
and plant samples, metal,
mirrors, plastic, velvet
2011
Courtesy of the artist

AS A SOCIALLY engaged artist, I not only make work about social issues, I also write, curate and run programs for artists. This extended practice both financially sustains and creatively expands my work beyond the studio, which, after years of struggle, I now work in everyday.

When I graduated from The School of the Art Institute of Chicago (SAIC), I asked a trusted professor to lunch to get some ideas about what to do next. She recommended I get my MFA at SAIC. I didn't want to do that though because I knew the statistics stacked against artists making work outside of school. I wanted to know if I would keep it up with the pressure of daily life, so instead I delayed graduate school.

My first job after getting my BFA was a short-term position at SAIC where I placed students in internships. When that ended, I worked in the public relations office at the Art Institute of Chicago. Seeing so many smart people working for pennies in windowless cubicles prompted me to try my hand at the for-profit world. I applied for a job at a television station as an administrative assistant to the CEO. After the interviews and tour, the general manager asked if I wanted the job, to which I replied, "Yes – everyone here is smiling." In a few months they promoted me to business manager, and asked me to start testing for the news. A year later, I created an arts reporter position. I thought that if I could make contemporary art accessible then the public could better understand and appreciate it.

I transferred those skills to National Public Radio (NPR) a few years later. As the visual arts reporter for an NPR affiliate, I interviewed artists, critics, curators and people on the street about what art means and what it can achieve. My favorite experience was in Houston during Robert Rauschenberg's ROCI show. I was seated next to a lively, elegantly dressed, elderly man at the press conference. He was Billy Klüver! That weekend I got to talk to him, Julie Martin, Trisha Brown and Rauschenberg. I felt like I had died and gone to heaven. In Chicago I talked with Andy Goldsworthy about the importance of failure when he realized his outdoor piece for the Museum of Contemporary Art (MCA) wouldn't work due to temperature fluctuations. In Washington, D.C., I visited the National Endowment for the Arts (NEA) to talk with Bill Ivey. His thoughtfulness about the rise and fall of the NEA helped me realize a much bigger picture than the little oil painting. Each of these men and women had not only passion and intellect, but a real willingness to risk failure in pursuit of their vision.

I came to understand that with all the vagaries of the art world, financial stability was crucial to my ability to sustain not just being creative, which can range from how one dresses to how one thinks, but also to maintaining a career and an identity as a professional, working artist.

After two years of matching my public radio salary in art sales, my husband encouraged me to quit my full-time job. I listened and took the plunge. During those transition years of irregular paychecks, I made ends meet by freelancing. Realizing that artists did not have the ability to contact whomever they wished to speak to like an arts reporter did, I put together a website to connect artists with writers and curators. This project started my path in grant writing and cat-herding (ever tried to get a group of artists to both agree and act on something?).

In 2004 I earned my master's degree, and was invited to do a big museum show, for which they would publish an exhibition catalog. About a year before the opening, the museum lost a significant amount of funding, so I found and co-wrote a grant to fund the show and catalog. In 2006 I birthed my first child, a thousand-pound artwork and a catalog covering nine years of

my participatory work. It was both exhilarating and debilitating, and I do not recommend this triple whammy to anyone.

I spent the next year fruitlessly trying to take my daughter to work (both the 36 sq. ft. rolling, carpeted playpen I built and the cadre of interns/babysitters I hired failed spectacularly, as my daughter wanted only me). I was exhausted and needed a break from the physical labor of the studio. The timing worked out well, as I foresaw the decline in the art market and knew I wouldn't be able to count on sales. Pregnant again, I knew we would be in Nashville for a while, and started thinking about how I could contribute to the city's creative capital. That year I started two ideas – one immediately realized and one that took time to cultivate.

After writing a couple of grants that didn't get funding, I eventually realized that successful grants required not just a good idea, but also a well-written narrative and a solid budget, sincere and enthusiastic support from partner organizations, no little amount of political lobbying, pointed feedback from a grant administrator, and a strong board of directors, all of which takes a heck of a lot of time. Being home with my daughter gave me space to formulate an idea worthy of such an investment.

In 2008, after securing significant funding from three sources, I launched "ART MAKES PLACE" (AMP), a year-long program that commissioned temporary, community and performance-based art for Nashville. Designed to encourage partnerships between artists and the public, we unveiled a work every two months, and continued its display for a year throughout the city. To culminate the project, we documented the work with a public exhibition and a catalog. It was amazing and humbling, and much harder than I anticipated. Organization was much more difficult than securing the funding. My worst moment occurred when an intern called from the middle of a busy intersection to say that a wheel had fallen off the large sculpture she was trying to move. My best moment was realizing that the seemingly disparate ways I had been trying to piece together a career are all part of the relatively new field called "socially engaged art."

As I was wrapping up AMP, I kept thinking about the space that I had built in my studio a few years earlier. I had built it to map out an installation that I wasn't able to travel for because I

was then pregnant. I didn't want it to be a gallery or a storage space for my work. I couldn't work on large studio projects because I had a baby and a toddler. I needed to be in the studio. That year Ruby Green, a contemporary art center in Nashville, closed. I realized that with my relationship with the non-profit, I was well positioned to start a space. I knew I could do a lot more with funding, so I wrote some grants and launched Seed Space, a lab for artists, writers and curators. Two of the AMP interns stayed around to start it with me. One is now a paid curator.

We kept Seed Space underground for its first year. Our main goal was to bring outside critics/curators to see and review the work for our exhibition brochures. While I started Seed Space as a way to get critics/curators to Nashville and my studio, it has grown important to the community, in part because of related programming. We do six exhibitions and two to three group shows a year, and are now planning to participate in international art fairs. We run the "Insight? Outta Site!" participatory pot luck forum, where artists meet nationally known critics and curators, and "Insight? Outta Site: Artist Engagement," whereby the Nashville community engages with visiting Seed Space artists. In order to support more locally-based, nationally exhibited artists and to raise funds for Seed Space, we launched "Community Supported Art," a program that sells limited edition works through a subscription service.

As a mother of two young children, I am now focusing on growing Seed Space and developing a new body of work addressing the health crisis, neither of which I could do without an extended and amazing network of supporters, ranging from friends and family to a slew of dedicated interns and assistants. •

I THINK EVERY artist dreams of living off the sales of their work, but all too often this dream does not become a consistent reality, and alternatives need to be found. And yet creativity also applies to this search for a viable way to earn a living and still maintain enough time and energy to focus on making art. I have been a professional painter for over 20 years, and making a living as an artist has always presented something of a quandary to me, having not wanted to go to graduate school and so never having entered the realm of academia. Ever since college I have just kind of fallen into the unofficial "catch as catch can" mode of operating. As a quintessential non-planner, I have always just managed to get into a variety of part-time jobs, a lot of which happened to be in publishing – either writing, or editing, or proofreading; but I have also done other things, from waitressing, to modeling for figure-drawing classes, to working for artists, but still always trying to prioritize studio time.

Looking back at the way New York City was when I got back after college in the early 1980s, I am struck by what a completely different place it was; the art scene was mainly in the East Village, the Meatpacking District really was just that, and punk rock dominated the club scene. There were tons of great places to see music, very few of which still exist, and it was still possible to find an affordable place to live and/or work. My first studio was in a basement on East 11th Street that I shared with a good friend from school, and we paid next to nothing for this

Amanda Church
Highland
59"x79"
Oil on canvas
2011
Courtesy of the artist
Photography by Jean Vong

great space that we could fix up exactly the way we wanted it. I worked the lunch shift at a Midtown restaurant, and would ride my bike down to my studio afterward. At night I often went out to see punk bands. It wasn't until I started dating an artist who already had a viable career that I began to realize what being a professional artist entailed: primarily, to start anyway, meeting other artists, dealers, writers and curators, and inviting them for studio visits. Once I began doing this, it quickly became second nature and was actually kind of fun. I was and still am a very social creature that thrives on interacting with others. It's a great way to establish a community or connect with an existing one, and it creates an intrinsic support system that I believe is essential to life as an artist.

Because of the way I've set up my life so as to keep expenses low, part-time work has sufficed to date. But with the current state of the economy and the accompanying lay-offs, including loss of health insurance, etc., times have become somewhat tougher, and I have been scrambling to replace a great magazine position with a variety of freelance jobs. With the exception of a couple of really good years, painting sales have not generated sufficient income to live on. So now I have found some regular freelance clients, and I also write art criticism for a few major publications. Additionally, I started a small design business called Mandy Pants, which has been in existence for about two-and-a-half years. First came the moniker and then the concept: a line of beachwear (board shorts and bikinis) whose designs are based on my paintings. This has been an interesting and somewhat successful experience, but I have learned that there is really not enough time to be a painter and to also seriously run a business. Painting has, and will always, come first. Interestingly, I have noticed a recent trend among artists to design clothes, including T-shirts, sneakers and skateboards. But then the art-meets-fashion thing has been around for quite a while: back in 2003 I designed a Fendi bag for that year's New Museum benefit, and collaborations between artists and designers are now virtually everywhere in the fashion world.

My paintings have evolved over the years into a recognizable form of minimal Pop, incorporating various aspects of the body in landscape, landscape itself and, most recently, elements

of hard-edge geometry derived in part from West Coast architecture. I've worked with various galleries in New York, Boston and Los Angeles, as well as in Europe, and recently had a solo exhibition in Louisville, Kentucky, at Land of Tomorrow, as well as a group show this summer at Kate Werble Gallery. At the moment, I am not affiliated with any New York gallery, and so have less to say about the relationship between artist and dealer, although my goal is, and always has been, to find a gallery that takes care of all business-related matters professionally, honestly and adeptly.

Because we as artists are so driven and committed to making our work, I believe that we will always find creative ways to overcome obstacles and support ourselves toward that end. That's what I see all around me, anyway, and I am proud to belong to such a dedicated, hard-working lot. •

EACH DAY I wake, put my clothes on, drink my coffee, wake my kids, make breakfast, pack lunches, take them to school and then drive to the studio. When I walk through the door I am comforted by the smell of oil and turpentine, and scan the room to take note of how I left it the day before. I stand in the midst of paintings that are propped up on paint cans and leaning against the wall, reminding me of the successes and failures of the day before.

Every day I create a problem for myself to solve, a battle that within my four walls is the only battle in the world. How the image presses itself against the edge of the canvas, how the colored ground seeps through, how the characters interact or don't interact with one another, how it reveals to me the delicate balance between my insecurity and my confidence. And then in the end, the satisfaction of knowing that it couldn't be any other way.

I knew from a very early age that I wanted to be an artist. It was the only thing that interested me and I was always making something. Despite my parents' concern that I might live a life of poverty, they supported my every decision.

I received my BFA from the School of the Art Institute of Chicago in 1994, during which time I studied twice abroad in Italy, and afterwards decided to take a few years off before going to graduate school. I moved back to my home town of Birmingham, Alabama, to find that I couldn't find a studio that I

Amy Pleasant
Untitled, On the Ground Below
45"x72"
Ink on paper
2011
Courtesy of the artist and Jeff Bailey Gallery
Photography by Jason Wallis

could afford. One of my best friends was the stage manager of the historic downtown Alabama Theater, and as I sat complaining about my studio situation, he suggested I come to the theater and look at some raw spaces in their building. The manager of the non-profit organization that oversaw the Alabama was interested in what I did, and wanted to support me somehow. He offered me a studio in the building for $35 a month, enough to cover my light usage. I became a part of the Alabama Theater family, and in this space I spent three years developing the work that I applied to graduate programs with. During this time I taught four days a week at an art studio for high-risk youth, taught private lessons, and after leaving the studio, I assisted a painter during these three years creating murals and decorative finishes in private homes. I painted on Fridays and any other time I could get on the weekends.

After finishing my MFA at Tyler School of Art, Philadelphia, in 1999, I moved back to Birmingham and resumed my work with the decorative painter until I found out I was pregnant and couldn't use the chemicals we were using on the job. I knew that I wanted to have kids and was concerned about how it would affect my career, but I'm a bit stubborn and determined and refused to believe that I should pick one over the other. I was going to do both; however, this decision played a large role in where I lived. My family was in Birmingham so it made sense to be there as they wanted to be an active part of my children's lives.

Where I live has been a large factor in how I survive as an artist. Living in an affordable city meant a less expensive house and studio, therefore leaving funds available to travel to see exhibitions, to visit with other artists, or for project opportunities. The amazing people at the Alabama Theater allowed me to keep my studio while I was away at Tyler, and I moved right back in after finishing my graduate degree. They raised my rent to $50 a month as I now had air-conditioning.

Living in a small town is made easier by having New York gallery representation at Jeff Bailey Gallery, with whom I have worked since 2004. Having this relationship relieves some of the feelings of isolation. I can participate in the larger art community while living outside of a major art city. We have a relationship that is both professional and personal, as he is

my dealer but he is also my friend. We talk a couple of times a month to catch up on progress of new work, opportunities that have come up, consignments or life in general. Despite the distance, we have studio visits at least twice a year. Other than that, we exchange by sending digital images.

Another gem about where I live is the incredibly supportive community of collectors that live in Birmingham. I am so fortunate to be a part of a tight and passionate group of people who have embraced my work.

I work a lot on creating relationships outside of Birmingham, in Atlanta, and in other surrounding cities, as there are so many great artists, curators and dealers in places close by. I need to engage with others in my field, invite them for studio visits and have ongoing dialog that feeds my studio practice when living in a smallish town.

Outside of sales of work, I currently teach two days a week and supplement my income by jurying shows, grants, project stipends, visiting artist opportunities and residencies (these are few and far between, as time away from home is difficult). So much of my growth is strictly about visibility, so I am continually looking for opportunities to keep my work out in the world, whether it is through my website or exhibitions.

I have found at this stage in my career that I spend more time on the business side than ever before. I spend hours researching artists, galleries, grants, project spaces, residencies, and e-mailing and reading about exhibitions as a way to stay informed in general. I try to schedule my days in the studio as a normal nine-to-five job would be, then family time in the evening, and then business work at night after my kids have gone to bed. I find that setting goals (monthly and yearly), and creating strategies to achieve them in very practical ways, is empowering.

Nothing is more critical to my process than time, and I found out quickly how to structure the studio in a new way after kids, as time was more sacred than ever. When I am there I have clearer objectives for what I want to accomplish each day. There is no room for waste. I try to not schedule meetings/appointments during studio time, and to keep clear lines around work and play, which requires a great deal of discipline.

I am confronted with obstacles on a daily basis, and my job is to find a way to persevere regardless. As I have gotten older, I have come to realize the sacrifices I have to make on a daily basis. Sometimes those sacrifices come in the form of things, sometimes it is a social life, and sometimes it is people.

During a critique in graduate school the topic of "life as an artist" ensued, and my painting professor, Stanley Whitney, said, "Even if you had every day for the rest of your life to paint, it still wouldn't be enough."

And it wakes me up each day. And I follow it. And at the risk of sounding melodramatic, it is the greatest thing I know. •

ANNETTE LAWRENCE

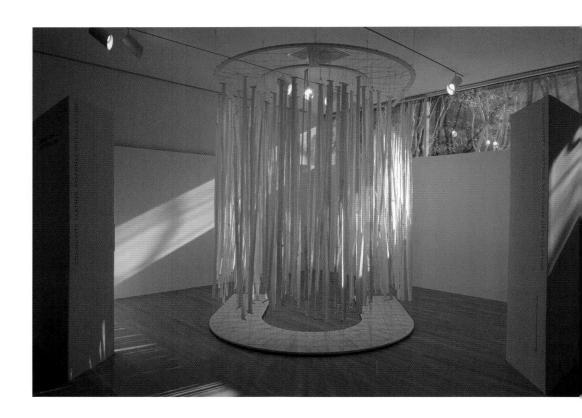

Annette Lawrence
Accumulation
Dimensions variable
Paper, tape, graphite, string,
wood and wire
2011–12
Courtesy of the artist and
Dallas Museum of Art

WHEN I WAS an undergraduate student, I worked in a pipe organ factory. My job was making the armature that sits in the pneumatic pouch, which is the smallest part of the organ. I learned, as much from the job as I did in my studio classes, that everything is made little by little, and process is key. Those lessons are the foundation of my practice to this day.

I am generally led by curiosity, and nothing is off limits. When I land on a subject or topic that I want to explore in my work, I leave no stone unturned. I tend to be methodical in my approach to learning as much as possible about whatever I am working on. A lot of time is spent inventing solutions to problems that I create as one thing leads to another. I often do not know what I'm doing, or where it's going. My work has centered on observing overlooked or underappreciated aspects of daily life. I have been interested in counting, records, measuring and marking time. Early on I was prone to compartmentalizing my life into two distinct categories of studio, and everything else. Over time I have allowed the membrane that separates my art practice from just living to become more permeable.

Reading, attending lectures and exhibits, seeking out films, concerts and performances, supporting artist friends and arts institutions – all play a large part in feeding my creative practice. Being an audience member and participating in a creative community keeps me informed about the work that is going on close to home and far afield. Journaling has been the most

consistent part of my practice over the years. Writing forces me to slow down and reflect. The chief organizational tools that I use to manage my studio are keeping a running to-do list and a calendar. Both become another form of journaling. Since my work is labor- and time-intensive, I set doable goals that insure progress from day-to-day. A day of work may entail completing a full stage in the process of making a large piece. The length of the day is determined by the time it takes to complete the goal. Typically an extended body of work will take two or three years to complete.

Balancing time and money is a continuous dance. I am able to function with just enough money in order to have plenty of time. Keeping my overhead low has been critical in regard to maintaining a time/money balance. I am temperamentally averse to financial uncertainty, so I have a regular job. University teaching is the base of my living. A portion of my income each year comes from sales of artwork, honorariums for lectures, panel presentations and collaborative projects. While I welcome these irregular infusions of cash, I need my money to come with the same regularity as my bills. Keeping a healthy distance between my art practice, the market and the demands of a career by buffering myself financially has been beneficial in sustaining my creative life. The pace and the progress of the work are determined internally, rooted in process, unfolding little by little. •

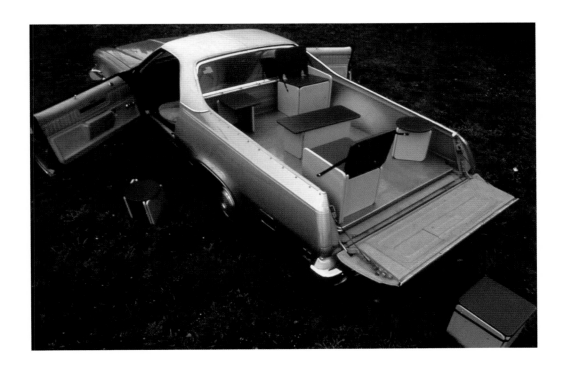

I WAKE UP at 5:30 a.m., with coffee and quiet fueling my ideas. The rest of the house, son and husband, get up at 7:00 a.m. when I call "breakfast!" I relish making this first meal of the day; cheesy scrambled eggs, cheesy grits, or bagels with cream cheese. Then it's off to work.

There are as many ways to be an artist as there are artists; Lucas Reiner told me that one, and it is true. I moved to New York to go to art school, and I thought an internship at Artists Space, a non-profit space known for supporting emerging artists, would supplement my graduate education in Studio Art with actual, hands-on knowledge of the art world. I worked there for two weeks and they offered me a job. Since I had only been in New York for a short length of time, I took it.

I was put in charge of the interns, and most of those individuals that were art students like me are still my friends. Years later, while working for Andrea Zittel, whom I met while at Artists Space, I introduced two former interns to each other and they married. Not only are they still my friends, I have shown their work through my various curatorial projects and they collect my work.

Real artists buy other artists' artwork. I say this one a lot and it has helped me out immensely. I once bought a drawing for $500, and when I needed money badly I sold it with the help of a gallerist for $3000. That money put food on the table and paid

Austin Thomas
Perchance: A Floating Scenic Overlook
79"x45"x27"
Painted wood with stainless steel hardware and cloth strapping fitted into the back of a 1973 El Camino
2010
Courtesy of the artist

the rent. I continue to collect art and I will sell something if the need arises.

I have also bought real estate; I think my mom suggested that one. She also loaned me the money to do it and I paid her back. My mom is an artist and a teacher. I showed her work at an exhibition space I ran called Pocket Utopia. It was a little like Artists Space. Pocket Utopia, which was located in the Bushwick area of Brooklyn, in a storefront space of a building I own with a couple other people, was an extension of my artwork. It was a place where my ideas expanded. My work extended into the community. I held salons on various topics, art historical and political, I editioned affordable prints by other artists, and provided space for other artists and myself to work in what I called a post-studio residency. I wrote about it all on a blog. I received numerous accolades in the press for my endeavors. I learned more about being an artist in those two years of running Pocket Utopia than in anything I did or have done since.

I have always had other jobs, primarily in the arts. My favorite one was working for *Harper's Magazine* for five years, where I selected art to stand alone on the page; not illustrating stories, but being a story. I went to hundreds of galleries a month. I even traveled to see shows in other places. I met other people looking at art for a living, primarily Jerry Saltz and Roberta Smith, both art critics and now my friends. I told them about the art I saw, they listened and I read their reviews, and when I liked what they wrote, I told them.

From working in the arts, to running a gallery space, to curating shows of other artists work and being a dedicated reader of art criticism, I have became a part of a community where I help people and in turn am helped. I want my work to be community-related but have a contemporary context, and I realized that by making public art. I have worked on public commissions and am working on one now for the City of New York. It is the biggest piece I have ever made. It involves working with a whole set of different people I had not worked with before, including curators, city planners and architects. It has been a big learning experience and I am trying to apply that knowledge to my work.

I like to collaborate and see collectors as such, and not as the rare person with extra income that buys artwork. I am a collector. I teach whenever I can. I have received the occasional grant so I continually apply. I might one day start my own foundation for artists, maybe even open another exhibition space, and I have experimented with teaching art to kids.

I know how to live on little because I have so much. I am married to an attorney who I helped put through law school. He thinks differently than I do, and therefore makes my ideas grow by challenging them. I have a really cute and smart kid who has taught me to "snuggle" and fall asleep at 9:00 p.m., so that I can get up at 5:30 a.m. refreshed and ready to work. ●

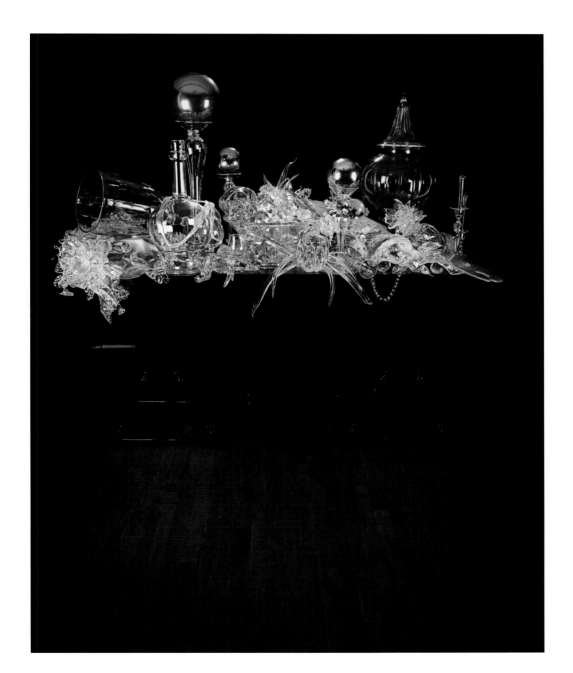

A BRIEF DESCRIPTION of my life at the moment: I am an artist, a mother and a wife living on a hobby farm in Sheboygan County, Wisconsin. My husband, Ken Sager, is the business and studio manager for my studio, which is located behind our house. We have a short commute. Every day, I spend three to four hours in the studio working on a variety of upcoming projects, and Ken spends three to four hours in the studio doing all the supportive tasks such as studio maintenance and upgrade, packing and shipping, component-making and taxes. When one of us is working, the other is spending time with the children. Most of the work for the past several years has been commissioned, or is for, a specific exhibition, and I am fortunate that I have been given opportunities to pursue my ideas and evolve my practice. My time within the studio is usually spent bouncing between different tasks, puttering around. I try to keep the kiln(s) firing every day, glue a little something here or there, make some work on the torch or clean and organize. All the while I am problem-solving the conceptual or pragmatic aspects of my practice. This goes on at all hours of the day: in the shower, running an errand, lying awake at night. It seems every so often there is an epiphany – some major shift in understanding about how the work is going to move forward, what is the next important thing. Most of the time it is smaller, more incremental steps forward and I busy myself with process.

Beth Lipman
One and Others
65"x78"x41"
Glass, wood, paint and glue
2012
Courtesy of the artist and
Norton Museum of Art
Photography by Robb Quinn

The sales from my work support my family. This is a situation I tried hard to avoid for the better part of my career, because I didn't want to be beholden to the marketplace. I used to be an artist, an arts administrator and a wife working full-time in the non-profit world, overseeing visual artists' residencies and education programs, working in my studio an average of eight hours a week. When my children were born in 2009, I was forced to choose between the security of having a job with benefits and being an artist. Ken and I realized that the occasional sales of my work were giving us essentially the same salary as my full-time job and that I could quit my job, which felt like leaping off a cliff. I think of this time only in months, not knowing how long the work will continue to sell and trying not to obsess about it. Fear is a tool – it is more frightening to think of not evolving within my practice than not selling the work. Every day, I feel so fortunate to be able to go into my studio and make art. •

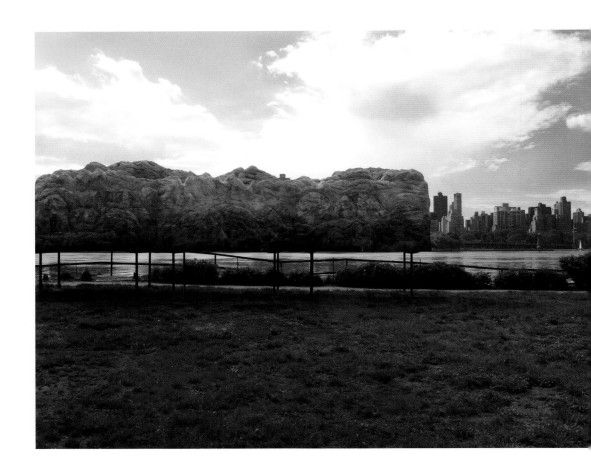

Blane De St. Croix
Mountain Views
13'x36'x6'
Fabricated from recycled foam
from the World Trade Center
site foundation construction for
Freedom Tower, as well as steel,
wood, paint, dirt, concrete and
stucco
Installation view at Socrates
Sculpture Park, Long Island
City, New York
2011
Courtesy of the artist

PROFESSIONALLY, WHAT IS most important to me is being able to make my work for a public audience. So, as a committed artist I figure out numerous avenues to make this happen, and provide for my compulsion. I do not see it as a detriment; the romantic notion of an artist only making work is an outdated one. Ultimately, being an artist is a profession like any other and involves a creative and business component. I feel it is important for me to be as involved in every aspect of my career as possible in order for the creative work to thrive.

I am an artist first, but also a university professor and teach my specialty of sculpture. I feel that my teaching is not just a job, but also an asset to my own work by being able to give back, foster a greater dialog, keep my own practice connected to the next generation, and the stimulus my students indirectly provide me. Some artists do not like teaching, but I find that it complements my practice – I have a good time in the classroom. In the spring and fall I allocate two days in the beginning of the week for teaching and one day for office-related work. I also commit time weekly for grant writing and applications. I compress my time so the remainder of the week is solely about art-making. The part of teaching that is stressful is not the teaching itself, but the administrative duties and the politics that surround the university. I keep this in perspective, and try to maintain a very good sense of humor about things. Finding time for it all is the most valuable commodity.

I maintain a rigorous daily schedule working in the studio. When I leave my teaching job, I absolutely do not bring it into the studio. Clarity is essential when I am developing projects, pursuing the research, and the actual creating and construction of my sculptures. My studio is my space; it is my private world, a place to escape for thought and creation.

A key to maintaining my pace and sanity is my calendar. Everything is scheduled daily and, when possible, well in advance. It is mandatory for all my art commitments, studio assistance schedules, appointments and business related travel – I fly a lot. I even streamline my travel with luggage that is never unpacked with trip essentials. I use the off-time in the airport or on the plane to answer e-mails or write.

Another key to my studio production are my invaluable studio assistants and interns. I find it refreshing to have company in the studio and hear others' perspectives. I enjoy showing them both the excitement and insanity of the studio. And I am always willing to share my insights to assist in the formation of their own early careers.

I also feel it is important to work in New York City, if possible, although it can certainly prove difficult for many. No other place has so much to offer an artist in terms of opportunity, exposure, motivation and dialog. And I do enjoy the social aspects of being an artist; life, work, friends, family – all are intertwined into my creative practice. I may attend an opening or party, but will often be in the studio working that day and if possible back that evening. I maximize my time – I usually work seven days a week. Seldom do I take a day off. It is not a sacrifice. I enjoy my artist life and need and want to be in the studio. It is a reward not a task. But, indeed, I am often pretty tired.

I have not vigorously pursued a commercial gallery. It has been a conscious decision to keep the work unimpeded by seeking non-profit project spaces, institutions and museums that would fund my large-scale projects and research. I also have been fortunate to receive numerous grants, fellowships and residencies that have provided an otherwise unattainable amount of support. This has allowed me to sustain my studio practice. The large arts grants have paid for the extensive research that my large landscape sculpture installations require, and in some cases the productions costs as well. My university

teaching position complements this by providing a stable and constant income for living needs and medical insurance.

I maintain a smaller live/work studio, and get larger space when big projects require it. This helps me maintain my overhead. I am also fortunate to have an amazing and supportive partner in my wife that understands, and is entirely supportive of, my art and my career. She is herself an accomplished artist and so she can see from our unique perspective. We occasionally assist each other in our studio practices, and are always aware of each other's studio art projects, events and commitments, taking part whenever schedules do not conflict. This has certainly strengthened our mutual tenacity with our careers. We celebrate each other's successes inside and out of the studio. And when she reminds me we need time to take a break, a vacation occasionally happens to a non-art-world-related place. ●

UPON FINISHING MY graduate studies in painting, I spent a year in New Haven, Connecticut, before moving to New York City to start my career as a professional artist. My home has been in various neighborhoods in Brooklyn for the past 20 years.

When I first moved here, I had to make a living working at various full-time jobs. I was then balancing my time with a relationship with another artist and the time I spent in my studio. It was important for me to set a goal of generating enough work so that I could start to work with commercial galleries. With the hope of sales from these galleries, it would be possible for me to find part-time work; and so I would be able to put more time into my studio practice.

It was a gradual climb out of this dependence on a day job. After having had my first exhibition with a gallery in Columbus, Ohio (the city where I went to school for my undergraduate degree), I started working with a gallery here in New York. The sales from exhibiting with this gallery, in particular, began to escalate. This was in the late 1990s, and I was for the most part putting all my time and effort into my painting. Even though the sales of the work allowed me to move away from my reliance on a day job, I still felt the need to work at a job in order to even out the periods when sales were light. Also, I could never trust that there would always be sales from my artwork.

During the years with this gallery, I was able to establish working relationships with other galleries outside of New York.

Brian Novatny
Untitled
10"x10"
Ink on paper
2011
Courtesy of the artist and
Mulherin + Pollard Projects

I was having two to three shows a year, and most of my creative output was in making work for those exhibitions. I was relatively satisfied with the kind of work I was doing, but, at some point, I felt the need to change direction in my work. I've always admired those artists whose careers went through a variety of creative transformations challenging what they know about themselves. I had reached a plateau with the work I was doing, and was caught in a cycle of repetition. Given the financial success I was generating, the galleries seemed to be reluctant to embrace much of a shift in one direction or another. I needed to work with someone where I could find some artistic solace.

It was at this time that I was introduced to a gallery in Germany. They gave me that latitude that I desired. I decided to take a calculated risk and move away from my New York dealer, and put my career into the hands of this dealer.

At first, sales of my work had slowed greatly and I had to pick up the income slack with freelance work, but eventually I was able to exert a presence into another audience. I had shown work similar to my older body of work with my new dealer with little success. Despite this setback, I saw an opportunity to shift the direction of my work. The dealer trusted my vision enough to give me another chance, and the changes were very much welcomed by the collectors.

This relationship continued to flourish with a lot of promise. Each shift and change was encouraged. For me, it was a perfect situation. Unfortunately, the economic downturn in 2008 revealed an unflattering aspect of this dealer, and the promise of any future with him evaporated. This relationship completely deteriorated.

Some time prior to this collapse in my trust of relying entirely upon commercial galleries for my income, I took it upon myself to go back to working full-time as an art handler and forgo freelance work as a safety net. I no longer had the flexibility of time, but now had the security of knowing how I would be able to live day-to-day. I had incurred a good deal of debt in that time, and needed to take care of this.

I had taken a sabbatical from showing with commercial galleries over the past four years, which ended with a recent show at Mulherin + Pollard in the Lower East. This show received a positive review in the *New York Times*. During

those four years without the watchful lens of the commercial gallery, I was able take the time to expand my work into a number of manifestations, which this gallery had responded to favorably. Now having a steady income from my day job has afforded me a new liberation, as I look forward to developing the relationship with this new gallery.

I have been working full-time as an art handler and trucker for the past six years at two different art service companies. Since I have the constraints of this schedule, I have had to be extremely frugal with my time and resources. Having my studio, my place to live and my place of employment in close proximity to one another is very important in order that I spend as much time as I can working on my artwork. Free evenings and weekends are spent in my studio. I do set aside time with friends and family, and have a very modest social life. •

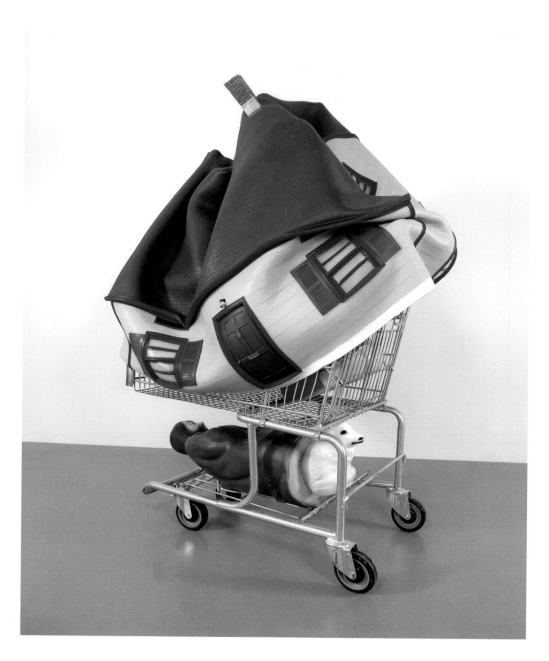

THERE ARE AS many ways to run an artist's studio as there are ways to make art. All of us are shaped by our personal and educational experiences. I didn't plan on pursuing a career as an artist. I was born into a very active political family. My maternal grandmother and three of her daughters served as presidents of the Tamiment Club – an old-school Democratic organization based in Queens, New York. My grandmother was determined to have at least one of her 18 grandchildren hold public office. As there were no takers, and I wasn't sure what to study in college, I chose Political Science. I studied at SUNY at Albany, where I spent my junior year as a full-time legislative intern. In the end it wasn't for me, and I turned to art for solace. Little did I know at the time how my political training would shape my art practice.

I took night courses at Parsons, and later enrolled full-time there while working full-time at Macy's. I went to school from 9 a.m. until 3 p.m. dressed in a suit and tie; at Macy's by 4 p.m. and worked until 11 p.m.; all of my artwork was produced between midnight and 4 a.m. I went on to Yale University where I received an MFA in sculpture in 1994. On graduating, I was fortunate to get gallery representation with Basilico Fine Arts, and was included in a two-person show at Artists Space called "Customized Terror," organized by Ronald Jones, my former professor at Yale.

Brian Tolle
Outgrown
58"x40"x80"
Toys, platinum, silicon, rubber
2009
Courtesy of the artist

My career as an artist had begun. Without thinking twice, a classmate and I took on a sublease for a studio in Williamsburg. We would worry about paying the rent later. During that time, I learned to create elaborate installations on the cheap. Styrofoam and sweat were my materials of choice. Skills, labor, space and equipment were exchanged among peers; cooperation came naturally to us by necessity. However, it didn't take long for money to become an "issue." Student loans and rents dominated our discussions. There wasn't enough time to produce two shows and hold down a job.

There are no bad opportunities if you have only one. Through one of my Yale classmates I met art director Marla Weinhof. She worked for prominent photographers, among them Richard Avedon and Steven Meisel. I started as a grip on the set for $100 a day plus lunch. More importantly, it afforded a lot of time to work on my art. Later I was asked to design and fabricate sets in my studio for designers such as Dolce & Gabbana. These jobs were great because of the fast turnaround and big budgets. That's how I funded my art.

Opportunity knocks. It wasn't until 1997, when I received a letter from Tom Eccles at the Public Art Fund inviting me to make a work in public, that I was able to make use of my political training. Having never done such a thing, I jumped at the chance. The budget at the time was about $10,000, about the same as I was being paid to build sets. I proposed a work titled "WitchCatcher" – a 26 ft. tall twisted "brick" chimney. Having no idea how to build it, I turned to family, friends and industry. My father volunteered engineering services. A friend turned me on to a product called Dryvit. Building a temporary public project presents special problems. The work must be durable enough to stand up to the weather, and portable enough to be installed and removed easily. The transition between making work for galleries and institutions and the public realm went pretty smoothly from a conceptual standpoint. "WitchCatcher" was my first project to use digital 3D modeling in its design. It was also my first project to be partially fabricated by tools controlled by computers.

Serendipity is underrated. In 1999 I was called to jury duty. We were sequestered and I got to know one of my fellow jurors pretty well. His mother, Joyce Pomeroy Schwartz, is a public art

consultant, and shortly after the case was over, I got a call from her asking if I would submit my qualifications for a competition that she was conducting for the Battery Park City Authority. I was the last person asked and the deadline was days away. I scrambled to put a package together. The project was the "Irish Hunger Memorial," which I completed in 2002.

Over the years, I have reached the point where I earn my living producing work for gallery exhibitions, private and public commissions, and teaching and lecturing. The scope and scale of my projects have grown – requiring collaborations with architects, landscape architects, engineers, lighting and sound designers. Moreover, my public art projects involved working with union contractors, public officials and community boards. At another level, teaching has been a very fulfilling aspect of my artistic life, allowing me to be connected to new generations of aspiring artists while mentoring them on the various creative and practical facets of an artistic career.

Ultimately, the key to running my studio relatively successfully has been my ability to interweave all these realms of art; to be nimble, to recognize the strengths and talents of the people working with and for me, and never associate myself with those who say that something cannot be done. Respect is also a key part of my business. I treat my assistants well and respect their opinions. Most of them are young artists, some of whom were former students. When it comes to critical decisions, I solicit the thoughts of everyone in the studio. In a profession ruled by deadlines, shifting priorities and unforeseen challenges, the ability to work well with others and to adapt quickly to changing circumstances is essential. I don't start any project – public or private – with a preconceived idea in mind. No concept or method is established until the work is finished. The best solutions sometimes come from unexpected places. •

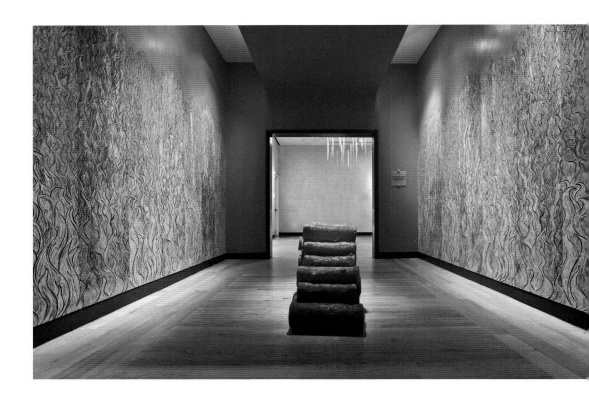

IN A TYPICAL week during the academic school year I spend three days a week at my teaching job, and three days a week in my studio. At least one full day and most evenings I spend with my husband and young son, and tend to household responsibilities. I use any spare moments – on the train, in my car, walking down the street and at the grocery store – thinking about my work. The demands of my life necessitate that I am supremely efficient with my time, and I try to flesh out conceptual and logistical problems as much as possible in my mind, so that the moment my foot crosses the threshold of my studio I am working.

The balance of this arrangement shifts during different parts of the year. During the summer I enjoy more time in my studio, and at various points of the school year my life is consumed by academic demands. When my son has a virus, I am home. Periods before exhibitions are always stressful, as I try to juggle these needs with my perennial responsibilities. Managing the dialectic of art, work and family requires my constant flexibility.

While there have been years my studio has flourished financially, this has never occurred consistently enough for me to quit the teaching job that allows me to pay rent, groceries and art supplies. Without my salary, there would be no balance for the lean times. I also take the avocation very seriously, and I have found the engagement of teaching has led me to think more creatively and deeply about my own practice.

Carson Fox
Fire Room
Dimensions variable
Cast resin, woodcut
2012
Courtesy of the artist

Since I had my son a few years ago, my life has changed, and I have had to look at my new limitations and prioritize. No force of will has allowed me to deny this reality; I simply do not have the same availability to make work, attend openings, do research or to apply for opportunities. Since the production of work has always been my most pressing concern, I consider this aspect of my professional life to be paramount. Unfortunately, this has pushed out other important aspects of my practice, and this is an ongoing, painful negotiation. I know there are opportunities I miss and contacts that are neglected as a consequence. I always wish I had more time. ●

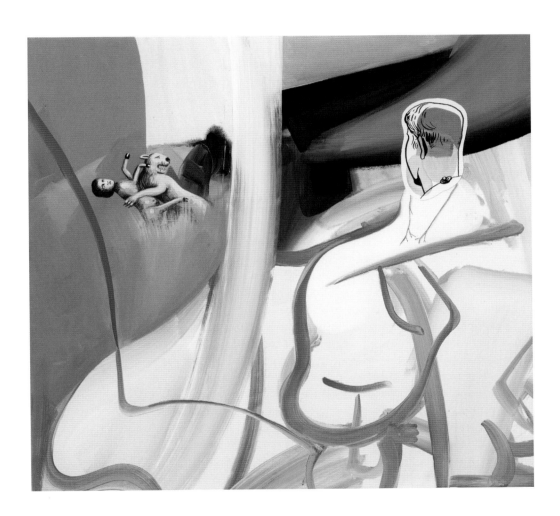

MOTIVATION MYSTERIOUSLY SWEPT over me, and I would descend into my family's basement to fashion chicken wire into big abstract shapes to be covered in plaster-soaked burlap. In high school I had no clue what the life of an artist looked like, but I knew, with a conviction cemented by more than one psychedelic experience, that making art was the *only* thing I could imagine doing in my future. My father and some of his friends were accomplished amateurs, but I was not at all curious about the practicalities of being an artist. I took some classes at the local community art center in Pittsburgh, and realized how much fun this odd sort of work was and that I could magically distinguish myself (even if I was stoned). A man named Charles Pitcher taught a painting class in which we copied his sequence of marks and gestures, so that each week we would return home with a painting of a large wave breaking over rocks, a dirt road crossing a grassy field and, ultimately, using his custom palette knife technique, a city of golden skyscrapers reflected in the water. My first paintings! I'm embarrassed at having included them in my art school admissions portfolio, but I got in and began a process of restless production and remedial education that has continued into my salty, late fifties.

But this short essay is supposed to address "living and sustaining a creative life." After grad school I did a lot of house painting with other artists who considered themselves proletarian/intellectuals, unsentimentally working to convert

David Humphrey
Witness
92cm x 92cm
Acrylic on canvas
2009
Courtesy of the artist and
Fredericks & Freiser

matter into meaning while resisting the status quo. Museums and libraries were our temples of mind expansion that harbored radical imperatives within their conservative envelopes. I had low expectations about selling work (it was the late 1970s/early 80s, and I was making not yet fashionable Pop-inflected Cubo-Surrealist paintings), but was eager to exhibit and participate in the urgent, rarified and diverse culture percolating downtown. The important problem, it seemed to me, was to establish and sustain a routine in which study and learning could be braided into the activity of making artworks in my own studio (while still being able to go to parties and nightclubs). I needed to harmonize the ecology of studio life with life in the world. The necessities and imperatives of one don't always support the other. The studio, for me, has been a space of expert solitude, in which the world outside can change dimensions like a mental image; reality is conjured, reordered and folded into a lather of drawing, painting and sculpture. Paying bills, maintaining jobs and relationships persistently threatened to pop this protective bubble of productive dissociation, while success itself created tasks and responsibilities that also encroached on the time necessary to sustain the very process that produced it.

Soon after I began to exhibit and sell work, I was asked by a couple of publications to write about art. I turned in a review to the now defunct magazine *Arts*, and a statement for the journal *M/E/A/N/I/N/G*. More opportunities followed, until eventually I had a regular column writing for the LA magazine *Artissues*. It was the late 1980s and I was getting a sense of how unpredictable a career could be and how artists, successful and unsuccessful, sometimes cut themselves off from the work of others. Writing about art was a way of being in the world while also bringing oxygen to the studio. Invitations to teach and curate shows followed, and I'm still doing both. It's a challenge to sort out why a particular artwork matters or, perhaps harder, why it doesn't; especially if it's a work you just made. Each wave of people making new work crashes into the language of contemporary art to unsettle and rethink it again and again. Sometimes it feels like I'm crashing into my own language the same way.

New York real estate is an important and difficult feature of "living and sustaining a creative life." It used to be cheaper here. There are compelling post-studio, virtual or tabletop options for exercising yourself as an artist, but I am entirely dependent on having a physical space that can function as both an extension of my body and a surrogate for the world: a clubhouse, playpen or dream factory. Space and time need to be purchased and it converts many artists into responsible money-makers, if not good citizens. It's an awkward point (like the artwork's commodity status) for the radical ambitions of contemporary artists (perhaps not awkward enough for some). Real estate is a conspicuous modifier of the meaning of painting and sculpture, with patronage and venue playing a big part. Cynics say, with some justification, that it is not what you show but where you show it that matters.

I like to believe (hopefully not too consciously and with a quotient of magical thinking) that each new painting has a transformational potential, that it could change everything! New images have the power to produce unexpected insights. An artwork (or even a reproduced image of one) can conceivably lodge in a person's brain to cause little changes that inflect the way they see, think or behave. Consciousness spills into the world; small actions flow into collective tides that reshape heaven and Earth.

But wait: exhibitions happen mostly in venues provided by dealers, institutions or artist impresarios. Professional courtships are negotiated by e-mail and telephone; some works are preferred over others, so compromising or "collaborating" helps. Fundraising for your own show? I think it stinks, but is sometimes necessary. It's impossible to know what will result from an exhibition. Art has value because people imagine it does. Art is a fragile and consensual fiction that requires great practical care while pretending to not care about practicalities. Artists frequently feel forgotten (and sometimes that feeling is justified), and so it helps to curate a show with yourself in it or have people come to your studio. My pattern, on days that I am not teaching, is to relegate all non-creative tasks (including writing) to the morning so I can be an unfettered artist in the afternoon and evening. At least one late night in the studio every week helps tremendously. •

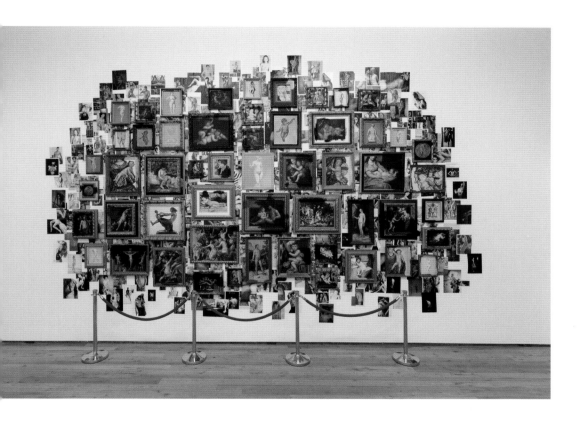

THERE ARE NEVER enough hours in the day. I always wish
I had more time in the studio, more time with my son, more
time with my husband, more time to see friends and just to
live. Because my work is generally very labor-intensive, and
because I've not really been able to outsource production in any
meaningful way, it's hard for me to keep up with the amount of
shows my galleries would like to do and all the other interesting
projects that come up. I feel like I'm always playing catch-up.
On the bright side, these are all things that I love to do so I feel
very fortunate.

I'm also lucky that I am not dependent on any one source of
income. That's been very helpful in these turbulent times. My
work sells well through my galleries, but I also do a lot of public
art commissions and some private art commissions. Much of
my work is also commissioned by institutions. I used to do
some teaching, but since the birth of my son I've cut back on
that as I already travel so much, and I want to stay near home
and near my studio whenever possible.

Having a child has been a great experience and also a
challenge. My career really took off after my son's birth, and
since my husband has a regular full-time job that doesn't have
much flexibility, I ended up adding the job of primary caregiver
just when things starting getting incredibly busy. It's been
interesting to me to realize how much time I used to waste. I've
pretty much stopped procrastinating; I just don't have the time.

Ellen Harvey
Nudist Museum
(installation view)
15'x18'
Oil paintings, magazines and
thrift store frames
2010
Courtesy of the artist and
Dodge Gallery
Photography by Etienne
Frossard

My studio is in my home, so I don't waste any time commuting and I can work with my son around, which is lovely. The first couple of years of my son's life I took him with me for all my projects, but now that he's in school he stays behind and my husband takes over. Whenever possible, they both come with me. Most of our family holidays coincide with my shows. It wouldn't be possible for me to have a career and a family if my husband weren't so supportive in every way, and if I hadn't been in the position to hire help when I needed it.

I work with four galleries currently, all of which are fantastic in their own way. Some are great at suggesting new projects, others go to lots of art fairs – they all offer different things. As I've grown older, I've become much more selective about who represents me. When I was starting out, I took what I could get; now I only work with people who are honest and who truly care about the work. I don't have time for the drama of dealing with galleries that don't pay their artists. Working with galleries in different countries has been great because it gives you access to different audiences – it's also fascinating to see how different the art world is in different places.

My relationship with my galleries is close and collaborative, but I make the final decisions, for better and sometimes for worse. I take care of documenting my work and keeping track of where my work ends up. I spend more time than I would like on running my studio, but I can't really think of how I would outsource that. I do have a wonderful assistant who helps with all the drudgery for which I am profoundly grateful. ●

I KNEW AT the age of eight that I wanted to move to New York to be an artist, and that's what I'm doing, so I feel incredibly grateful.

After college in 1989, I got a job at an advertising agency. It started as a temp job that I got through my friend Linda Simpson. Jane Folds, the HR director, an impossibly cool ex-beatnik, offered me a permanent position, but I didn't want to take it; finally I relented, and joined the nine-to-five world. I quickly got promoted with ensuing raises and benefits, and four years later I got fired; yup, the best thing that ever happened to me. I was ready to start showing my work, so I asked my friend Ellen Birkenblitt if she had any ideas of who might be interested in what I was doing. She suggested I contact Bill Arning at White Columns and the rest is history. Fast forward to the present and after seven solo shows, a fantastic collection of art on my walls from trades, and the realization that I am living exactly the life I wanted to live, I have to humbly say thanks to everyone who has helped make this possible. In addition to my talent, I've been helped by a group of incredible, supportive friends. Honestly, I gotta say the art world is so full of kind, genuine compassionate people, from the young students I know to the superstars. I feel very lucky to be a part of this community and to be living the life I am living.

Erik Hanson
Shout
36"x48"
Oil on canvas
2012
Courtesy of the artist

It hasn't been easy, but it has been worth it. I've weathered the jealous boyfriends and bosses, unstable income and some very close financial calls.

My last full-time job was at a mannequin factory; this was from 2002 to 2005. It was a fascinating job where I learned how the human face was put together. It made up for the anatomy class I would have had if I had gone to art school, and now I can paint portraits as a result. My boss did his best to make it miserable for me; he could barely contain his jealousy and contempt of the art world, which stemmed from an early rejection that he never seemed to get over.

Since then I've paid the rent in a variety of ways – from bartending, selling things on eBay, being a foot model (don't ask), renovating apartments, the US Census and unemployment, and I do have the occasional art sale.

Collectors buy my work with some regularity, but I never know when it's going to happen. After the crash of 2008–09, things really slowed down though. In the fall and winter of 2009–10 I had a few sales lined up with collectors who had put a substantial amount of work on reserve. I assumed they would follow through over time and complete these purchases, but then the economy kept worsening, and for many collectors, they were buying less and less art, so these sales fell through en masse. I had been letting some of my bills slide (like rent), as I assumed I'd be getting a large sum in the near future and could take care of my bills when the sales went through. When it finally dawned on me that they were not gonna happen, I was six months behind in my rent and my landlord was taking me to court.

I was facing some serious financial trouble, and I asked my friend Bill for some advice; he came up with the idea of offering a small amount of work at a low price. I had a group of paintings from 2006 to 2009 that had been shown a lot, and I had already sold a lot from that group as well. They were my first real credible paintings, and once I got it down, I made a lot of them and I still had a fair amount of them left, so I sent out an e-mail offering the smallest ones for a really low price and was flooded with responses. Many people wanted to buy them, but a lot of people were just like me – facing economic challenges of their own – and could only offer support and encouragement. The responses

blew me away. The good wishes and words of encouragement I received were priceless, and for many of my friends in similar situations this was an opportunity for them to talk about their financial problems. Many people were relieved to know that it wasn't just them; that others were in a similar situation and, for them, the knowledge that I could get through this was a sign that they could too.

This near catastrophe ended up being an incredible experience for me. I've reconnected with a lot of old friends, cleaned out my studio a little bit and my work is on a lot of new walls.

I also received a call from a friend who had been staging apartments for sale, along with styling for photo shoots, as a way to supplement his income, and since then I've been assisting him and others doing the same kind of work. •

GEORGE STOLL

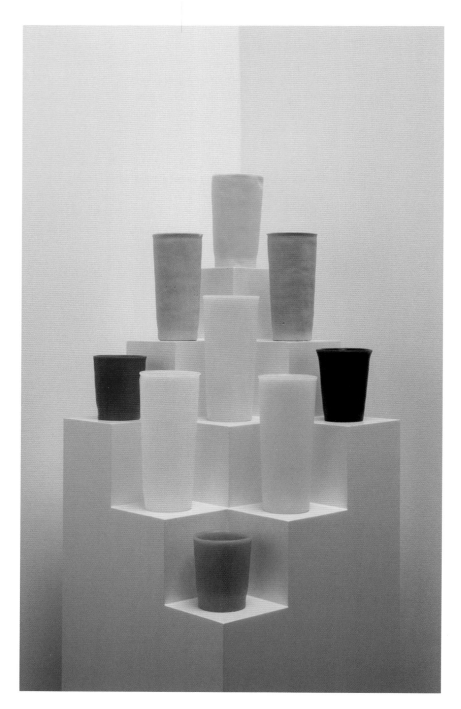

I LIKE TO work but don't always like to start, so I make it as easy to begin as possible. At a restaurant near my house that has good coffee, friendly waiters and an owner who tolerates my long visits, I start most days. Being with other people who are working helps me focus, and here, surrounded by the bustling restaurant staff, I can read, write, sketch or just plan out my tasks for the day. As I usually work in my studio alone, this affords welcome relief from the solitude and gets me out the door in the morning. Nearby I can easily buy art supplies or groceries, go to the gym, or to the library, where I borrow books on tape that keep me entertained while I work in my studio. Over time, it has also become apparent to me that I like to play hooky, so I will often begin exploring a new idea when a different, more pressing project is due. My school attendance was always spotty, so I've learned that I am especially productive when feeling a bit delinquent.

For the past 20 years or so, I have been able to support myself from the sale of my work. This means I sometimes live well and at other times marginally. Keeping my overhead low is one way of maintaining my focus on a creative life. One of my economies is living and working in a one-bedroom apartment. What previous tenants had used for a living room, I use for a studio, and the little dining room doubles as my office. I've been able to tame my freely spreading work space by renting storage nearby. By being somewhat strict with myself, I am able to keep

George Stoll
Untitled (9 tumblers on a stepped corner pyramid) #2
12"x64¾"x12"
Beeswax, paraffin, pigment, plywood and paint
2012
Courtesy of the artist
photo by Ed Glendinning

the kitchen, bath and bedroom designated for their original purposes.

The first time I sold a work of art, the big surprise was that I, all of a sudden, had a business to maintain. Up until then I took art-making seriously, but paying taxes on the income shifted my awareness. It's been useful to think ahead by breaking all my income into percentages: 20% for savings, 30% for taxes. This leaves 50% for me to live on. This practice can be especially helpful when sales are slow at the end of summer, or around the Christmas holidays, and at tax time. I would be less than honest to say that I don't rob from these accounts when I need to, but even in the leanest times, breaking up the periodic windfalls from sales slows my spending. I also plan ahead more practically when I have only 50% to spend on rent, food and entertainment, which includes coffee at my favorite restaurant.

Being self-employed, I am susceptible to the impulse to work every day. To avoid burning out, I take one day off every week, which translates into no work, errands, cleaning or laundry on Sunday. One day a week I just eat, watch movies and generally loaf. The double benefit of this discipline with myself is that not only do I really look forward to Sundays, but I also usually look forward to Mondays, eager to begin working again.

Over the years, I have worked with many dealers. These relationships seem to go best when we discuss business well in advance of a show. I composed, with a colleague who formerly owned a gallery, a consignment agreement that covers most of my concerns, some of which are: Who is paying for the frames and pedestals? How long is the consignment for and, if the show is out of town, who is paying for shipping? Most consignments are for six months with the option to extend. This is especially important after a show when unsold pieces need to be returned to me and the possibility of a sale has softened. Another surprise was the convention of discounts. Collectors often ask for one. By predetermining with the dealer what the shared discount will be, this clears the path for them to negotiate with the collector, and protects me from unpleasant surprise adjustments in the price. A dealer will sometimes combine several pieces from different artists they represent, and a discount gives them the ability to sweeten a deal. I don't mind sharing a 10% discount, but ask

to be consulted on anything larger. Package discounts seem to be a standard practice in all sales fields – be they diamonds, contraband drugs or fine art.

The art world is growing, international and tiny. While I'm often critical of it and find the caprices of the market sometimes disheartening, for the most part it is a community of smart, curious and committed people who share a lot of the same interests and passions. I am almost always reassured at how serious and interesting most of the individuals are.

The interrelationships between artists, dealers, collectors, curators, historians, etc., are symbiotic. We're all in it together. At one of my first studio visits, I was given some valuable advice. The dealer suggested that I show my work to other artists. This has proven to be solid. Other artists introduced me to my first dealers, and also curated my work in the first group shows I was part of in New York and Los Angeles. I have also had the pleasure of introducing other artists I admire to dealers and collectors.

I like the challenge of making art and my primary motivation is curiosity. I really do want to know what something will be like if I make it. The most satisfying aspect of being an artist, for me, is to spend most of my time working out ideas. From the beginning of mankind, some of us have been artists, and my intention is to contribute to this ongoing and ancient conversation. •

IN AUGUST 1996, my fourth year of undergraduate school, I attended a studio program in New York – the New York Studio Program (NYSRP). It brought together eighteen students from the US, and put us in a great studio space in TriBeCa for one semester. I grew up in Charleston, South Carolina, was attending art school in Florida, and had never been to New York. This changed my life. We were put into an environment modeled after a graduate program. I interned at Jay Gorney Gallery, and subsequently started assisting some of his artists. I made a lot of friends, made a lot of work, and worked. In January, I moved back to Florida, worked in a bong factory and a ceramics foundry – those skills going hand in hand – and graduated in May. Three days later I drove back up to New York in my friend's truck.

After spending the summer in a tiny closet-sized room on 11th and Avenue B, I moved out to Williamsburg. This was 1997, and it was a weird empty place. You could be the only person getting off the L train on a given night. I'm sure anyone who was out here before that would argue a bigger "back then" story, but whatever. The neighborhood was great; it seemed that everyone getting out of art school landed here, and it was cheap. I moved into a giant warehouse (which is now the Northside Medical Clinic and a bar) with my friends Claude Collins-Stracensky and Mindy Shapero, both of whom I met in the studio program. They eventually moved to LA for grad school, and are both still

Jay Davis
Please, no more birds
30"x24"
Acrylic on panel
2011
Courtesy of the artist

out there making great work. With the exception of Graham Parks, who at the time, prior to becoming a working artist, was a baker, we all worked for different artists and galleries. We built our place out, rented from the Mob, and had it bulldozed three years later with two weeks' notice.

While there, we all found time to make our own work on days and evenings off. I kept a studio in that cavern, with four others living and working, for two years. I worked for James Welling in his studio on Greene Street, who introduced me to his friends and artists, which I ended up working for also – Joseph Bartscherer and James Siena. Jim (Welling) was nice enough to give me some work when I called him after arriving in New York, post graduation, broke and unemployed. After building some walls and crates for him while in the studio program (he was showing at Jay Gorney), he told me he needed a lab tech in his studio. I had no idea what being a lab tech entailed – I had never done anything at all with photography, much less developing and printing. He said that was fine, as he really didn't have a lab yet, and was sure I could pick it up. We built a darkroom in his laundry room, exhausted it with a Vornado fan and some duct work. Top floor walk up of a building he lived and worked in (prior to moving to LA full-time to head up the grad photo program at UCLA), hot as hell in there all summer. His building was full of artists that had all moved in and grabbed space when SoHo was what Williamsburg was at the time.

In 1999, I realized how much work I wasn't getting done with the distractions inherent in living and working in the same space, and sharing it with four others complicating that. So I rented a space in a former chicken feather-cleaning warehouse a few blocks away. I built my space out, and that is the studio that I'm still in. I've moved apartments a few times, always trying to keep the distance to the studio down to a minimum. Over the course of those first few years in New York, I worked (and did odd jobs) for a long list of artists – James Welling, Joseph Bartscherer, Lothar Baumgarten, Alan Sonfist, Vito Acconci, James Siena and Brice Marden. Some of those experiences were amazing; in a way a further education for me. Learning that everyone's career has its ups and downs was something I'm glad I learned early.

I also did work art handling for galleries, ending up at a more permanent job as the preparator for Tom Healy when he had his gallery of the same name, shortly after parting ways with Paul Morris (Morris Healy Gallery). My schedule for Tom was great, and so was working for him. I would go to the studio every night after working at the gallery (or for one of the artists I worked for off and on, or some random carpentry work, etc.) and work late, rolling in to work during the day, also late. Tom closed his gallery, I think, around 1998. In those last days of the gallery, his director stumbled across some of my slides, and showed them to him after work one day. Tom liked the work – he called me, asked why I never showed him my work while the gallery was actually open, and bought a few pieces from me. I think I wanted to sell them for $500 each or something like that. He told me that was crazy cheap and was generous with what he handed me. He also put me in contact with Brice Marden, who was looking for an assistant, and with the gallery closed, I was obviously out of work.

I worked for Brice for a little over a year, then took some time to get my work together to apply for grad school. That December, Tom Healy called and said he had a holiday party where Stefan Stux had expressed some interest in the paintings of mine he saw. I made an appointment to show him some work – my sheet of slides I was putting together for applications – and met him before the holiday. I almost left after going in there twice and he wasn't ready or wasn't there, but eventually got to meet with him and set up a studio visit for two weeks later. He came by in January, and asked if I could finish up the work in there for a show in three months. I think he had a vacancy to fill, so I said yes, and lived off a few odd jobs and my credit card until April, hoping to sell maybe one or two pieces and pay my card off. After only doing a few group shows in New York up to that point, I was really excited and a little nervous at the opportunity. I was also a bit naïve going in – I actually signed a contract, figuring I was only 24 so what harm could a three-year contract do? I don't think a contract given by a gallery could ever really be in an artist's best interest, but after a lawyer told me it would probably never hold up in court, I signed it anyway.

I did the show and it sold out. And things kept selling. So I put grad school on hold for a little while. I got a call from

LIVING AND SUSTAINING A CREATIVE LIFE

Shoshana Blank, from Shoshana Wayne Gallery in LA, after a friend of hers saw my work during one of those group studio tour things that nothing good ever seems to come out of. This time it did, and Shoshana called every Jay Davis in the Brooklyn phone book. We set up a date to meet and have lunch a few days after my second solo show with Stefan opened – for September 11th, 2001. That meeting eventually took place a few months later, and I did my first show with her that next year.

I was introduced to Mary Boone in 2001 through Max Henry. He was curating a show called "Westworld," and wanted me to be in it. I was really excited. Then I got a call from him saying she didn't want me in it. Ok. That really sucked. He arranged for her to meet with me at my studio, and Stefan wanted to be there. So we set a date and time. With only five minutes warning, I got a call from Mary on the Williamsburg Bridge. She was running very early, so that took care of Stefan sitting in on the visit.

I was pretty intimidated, and only assumed she was coming by as a formality, and I would be crushed and miserable after. She showed up, was very pleasant, looked around while drinking a bottle of water I offered her, apologized to my assistant for talking on her cell upon being let in to the building, and told me she wanted the big painting I was working on in the show. Then she asked me what my future plans were, if I was attached to Stefan, and said we should talk about doing a show. Wow. That was not at all how I thought it would go. She left and I was in complete shock. I'm still not sure if that was a strategic way to come by my studio *sans* Stefan, but assume as much.

I did my first solo show with Mary in 2003, at her 5th Avenue space. I figured I wouldn't be going to grad school at that point. The first thing I did after the show was pay off my undergrad loans. I think I was the most reasonably priced artist in her stable, and found much of the rumors I had heard about working with her to be not entirely true, at least for me. Definitely no stipend, and I was still paying for my studio and assistant. And I got along with her very well. My friend Chie Fueki, who I lived next door to in Florida and had a studio next door to while in school, started showing with Mary and Shoshana as well. I've always tried to bring in friends whose work I respect into the galleries I work with.

After my second show with Mary at her Chelsea space in 2005, some time and some mild disagreements, we parted ways in 2007. Keeping my gallery in LA, and watching the economy tank, I decided to branch out to some smaller, young galleries outside of New York; spread my losses, I guess, as much as possible. I did some solo shows in Chicago, Tokyo and Houston, with Texas being a good choice, as they seem to have their own economy that didn't get hammered as much. I also started to sell out of the studio, taking advantage of not having New York representation, but also being careful not to stir up any conflict with Shoshana or any of my other galleries.

I've tried to keep my career, lifestyle, etc., in perspective – never overextending myself. I didn't (as many of my peers did) go out and get a 2000 sq. ft studio with five assistants immediately after some success. That proved to be a bad idea for many of them. I kept my same studio space, only have help in here when needed, and invested my money over the years. Now after being my own New York representation for a few years, I think it's time to find someone again who can take care of all of that for me. ●

Jennifer Dalton
Only in America (Or, I Can't
Trust Myself)
68"x22"x12"
Approximately 700 custom-
printed temporary tattoos in
plastic capsules in two vending
machines, on painted wood
pedestal
2011
Courtesy of the artist and
Winkleman Gallery
Photography by Etienne
Frossard

I REMEMBER THE first time someone told me that many artists with apparently thriving careers and gallery representation still had day jobs. It was the first of a very long series of realizations that the art world is at least 50% smoke and mirrors. At the time I felt an almost personal betrayal at the realization that artists I had already perceived as incredibly, unattainably successful still had to find another way to pay the bills. Many years later, I still haven't really gotten over it! Tons of brilliant and well-known artists (and curators, and critics and art dealers) are utterly broke, working full-fledged outside jobs, relying on money from their families, or some combination of the above. The art world is a hard place.

Over the years I've carved out a way to make it possible for me to keep making art and not give up. Everyone's path is different, but here's mine. First, I've had the same low-level day job for 18 years. Over the years I've become really good at it, and I now find it very easy. When I was 26 I moved to New York from Los Angeles to go to graduate school at Pratt Institute, and started looking for a part-time job to supplement my student loan "income." I was hired two weeks after my arrival here for the job that I still have. I have never attempted to move up in the company because I can do this job and still be an artist, but I'm not sure that would be true for other more demanding jobs. Over the years I have been a full-time, part-time and freelance employee; I have taken leaves of absence, quit, been laid off and

been rehired. For the past several years, I have worked only part-time and primarily at home, which has made my life much easier. I've kept my foot in the door at this job even during the few heady moments when I thought this art thing might really be about to pay off, and I have not been sorry. The job has been a huge part of how I've been able to sustain my life.

Since 1997, I have been in a relationship with a lovely person named Wellington Fan, who, unlike me, has skills that our mainstream culture is consistently willing to pay for (computer programming). For most of this time, Wellington has had a full-time decent- or well-paying job. For all of that time, he has been extremely supportive and patient with me and the financial ups and downs of my life as an artist, and I am very grateful for that support. In 2003, Wellington and I were able to buy a small house on the eastern edge of Williamsburg, Brooklyn for what now seems like an insanely low price. I have worked in a studio at home in a converted one-car garage for the past nine years, avoiding paying studio rent until about two months ago, when I started renting an outside studio space. I am nervous about that decision, but there were some good reasons for doing it and so far it seems to be working out.

In 2004, we had a son. I worried it would be impossible to be a good mom to him, continue to make art on a professional level and balance the day job as well. It turns out it was possible, just not very easy. Until Oliver went to nursery school, we shared a wonderful part-time nanny with several other families. She watched Oliver and another kid together two days a week when I went to my day job. We could only afford for me to take two months' unpaid leave from my job when Oliver was born (I had been freelance at the time I got pregnant), and I fretted unbearably about the first day I was supposed to go to work and leave my little son with our babysitter. But as I walked to the subway with the unwieldy annoying breast pump bag over my shoulder, I realized those work days were going to be days of rest compared with taking care of my infant baby, and I started to feel giddy (and guilty) with the tiniest bit of regained freedom. I also worked another 15 hours per week for my job at home, but spread out over the rest of the week when Oliver was napping or at odd hours of the night. I do not think I made any artwork

in those first several months. But then when Oliver was about 8 months old, I was offered a Smack Mellon studio residency that came with a stipend. I had applied many months previously in a spasm of optimism, even though it seemed unlikely that I could manage to accept it even if it were offered. But I realized I could use the stipend to hire our babysitter one extra day per week, and I would go to the studio for a whole day. That residency made an enormous difference in my life; it got me working again and reminded me I was still an artist.

I know there are many who consider this decision the height of selfishness, but we never considered having more than one child. Our family feels complete; our son may have no siblings but he has relatively happy and sane parents. It's possible he'd prefer the opposite at some point, but I'm hoping not. Oliver is now eight years old and a sweet, happy kid. He has now been in nursery or elementary school for five years. Since Wellington works a job with a standard schedule, I have always been primary caregiver, which in practical terms means that, unless we hire a sitter, I pick up Oliver when school gets out and I'm forced to stop working and hang out and goof off with him. It can be agonizing to start wrapping up the day's work at 3:30 in the afternoon, but it's good for me and it's good for Oliver. So for the past several years, my day job and my artwork mostly exist between the hours of 8 a.m. and 4 p.m. Monday through Friday. I have found that I have become a much more productive artist and worker since I've been forced to be. There is not much time to waste. When things are really tight, I work at night after Oliver goes to bed, but usually I'm too worn out. On weekends, we mostly hang out all together unless Wellington or I desperately need the time to work. Some other artist parents tell me they can get work done with their kids puttering around the studio, and I admire them incredulously.

In 2001, I met Ed Winkleman. He and I were both involved as curators (there were many other curators as well) for a weekend art show in Brewster, New York. We had some good conversations and he agreed to do a studio visit. He sent Joshua Stern over to my studio a few weeks later. The two of them had just opened a very small gallery in Williamsburg called Plus Ultra. I thought they both were fascinating and smart, and

they liked a project I was working on (the beginnings of "What Does An Artist Look Like?") and gave me my first show at the gallery in 2002. My relationship with Ed has been one of the luckiest, most generative and sustaining aspects of my artistic life. My conversations with him about art leave me inspired and challenged, and sometimes even frustrated – but in a productive way. Sometimes when I'm stuck with a piece, he thinks of a great idea to try, and sometimes when I think I'm not stuck, he tells me that he thinks a piece is not as good as it could be. Sometimes I decide he's wrong, but often I decide he's right. I feel like we have a partnership.

That brings me to the last aspect of my life that I think has been crucial to my continued ability to make art and keep caring about it: my community of artist and art-involved friends. After graduate school, some friends and I started a crit group that we sustained for several years. That group – both the continued schedule of studio critiques and the intelligent, competitive opinions of its members – forced each of us to keep making work when no one else cared whether we did or not. Most of the members of that crit group are still making and exhibiting art 10–15 years later, and many of us are still close friends.

In the past several years, as my artwork has begun to encompass social and collaborative aspects, my art community has grown to be much larger and more interconnected. I have begun collaborating with other artists on projects: first Susan Hamburger on a paper zine called *Broadsheet* we started in 2003 and still intermittently produce; and then William Powhida, with several projects beginning in 2008, the most insane of which being "#class" in 2010. These collaborations have forced me to grow new ways of thinking and dealing, and these relationships have become crucial to my art life. Collaboration is grueling and incredible. I highly recommend it for getting out of your own headspace, which we can all start to privilege a lot more than it warrants. I find other artists' (and critics' and dealers') engagement, competition and even criticism to be a continuous source of energy in the studio. I know many artists prefer to work without much "interference" from outside the studio, but I continue to be inspired and challenged by the smart people around me, who make me always want to be a better artist. ●

I STARTED CREATING art while still in high school in Athens, Greece, and had exposure to contemporary art as a child through politics, literature, theater and music. It was not until I moved to New York to study "art" when I believe the combination of New York City in the late 1980s and that of the academic environment pushed me towards professional art. I enjoyed theoretical debates, and practicing art was a way to stay grounded, and at the same time free and use my mind. Of course, I think that by sliding into the art with my Greek background it made me sensitive to what was being overlooked in the dominant discourse on a variety of aesthetic, affective and social levels. I supported myself through school with the help of my family, who continued to live in Athens, Greece.

After I finished graduate school, I supported my creative ambitions through all kinds of jobs, and eventually earned a position as a photojournalist for Greek/American publications in New York City. I enjoyed that job very much because it offered access to all kinds of people, and allowed me to collect visual and oral material, which I was later able to publish in a book under the title *The Great Longing: The Greeks of Astoria, Queens*. After the publication of my book, I started teaching as an adjunct professor at The New School, as well as photography and studio classes at Cooper Union School of Art in New York City. At that time, I thought it more stable than being just a photographer and a practicing artist. However, I soon realized

Jenny Marketou
Red Eyed Sky Walkers: Silver Series
Dimensions variable
Mixed media, site-specific, network outdoor/indoor environment; Kumu Art Museum, Tallinn, Estonia (European Capital of Culture, 2011). Commissioned by Kumu Art Museum and sponsored by Goethe-Institut
2011
Courtesy of the artist and Kumu Art Museum, Tallinn, Estonia

that I was wrong, because like other artists who teach as adjunct professors, I was surviving on a teacher's salary with no benefits or health care.

After talking with other artists and hearing about their precarious situations, the siren song of our information culture insisted that I too can prosper from my inner creativity, and I decided to support my creative ambitions as a self-employed artist, and put all my energy on my artwork and chose my own fate. But this is also difficult, as I'm an artist, not a business person. Making money seems to elude me. I'd rather make art without thinking about finances, but I guess that's also a silly dream.

I guess there are many reasons that we remain silent about labor conditions in the art world. The world of art is entrenched with issues of class and dependence on corporate monies, and the artwork has become the only focus, which probably explains why so little attention is paid to the conditions of artistic labor, even among artists themselves.

Instead of full-time teaching, I chose to be hired only for visiting artist positions when available, or giving talks and participating in panel discussions. Of course, my practice being in the realm of the experiential using video, film, installation performance, Internet photography as work tools, experimentation and analysis, and although my art process is the result of a lot of labor and research, it has remained oppositional to the gallery system. And rather than hide behind the false idealism, I am forced to find alternative ways to make my living and support my studio and my art practice. I have decided to engage myself in long-term and short-term projects which engage new audiences outside of the art world – and which can be sponsored and commissioned by alternative art economies and shown by museums, festivals, foundations – and which open the very system of the art world to critical contemplation worldwide. I find myself using the museum gallery, the public squares, subway platforms, streets and protests as site of production, where the work is produced and supported by commissions, artists' fees, grants or in-kind sponsorship from education departments.

I have also engaged myself in the administration of my work, and sometimes I feel like I am running an office. I came to realize that to be relatively successful artist I have to become a knowledge entrepreneur – a free agent, like other "creative" workers, scrambling to wind up on the right side of the ever-widening have/have-not divide in search of greater financial security. Even in relatively good times, I find myself in the need to cope with tireless self-promotion and networking. To realize each art project requires a lot of discipline and focus – long hours, lots of traveling and global transit – with constantly shifting conditions into collaboration, and alliances with people from other creative disciplines hailed to be present though the entire production and presentation of each of my projects. I spend most of my holidays envisioning and drafting proposals, trying to find potential projects which will support my work with all production costs and artists fees, along with a budget for a publication.

My work will continue to be dispersed and remain presented throughout the world's peripheries, museums and biennials, instead of being stockpiled in some central factory of contemporary art. I refuse to be depressed about what happens in the art market, and I am always willing to act, to take risks against the status quo, and to create the kind of work that I want to do. This gives me the inspiration and energy to sustain a full creative life, and a career that continues to develop and grow over the years. •

FOR ABOUT THE last seven years, I've been trying to figure out how to do my own work and take care of family at the same time. I'm still figuring it out – and about the only thing I know for sure at this point is you can't do everything well at the same time. Something's gotta give. So, when I'm starting a new piece, I've figured out the best thing to do is to just give myself permission to be a really bad mother for a few days. This means the laundry usually gets forgotten and the clothes in the washer end up going sour. We eat trashy take-out like Taco Bell. And if my son, Owen, who's 12, wants to have Nacho Cheese Doritos for dinner, I very well might say okay. I just have to pick and choose my battles. He spends way too much time on his Xbox, and I can't always make it to his soccer games. Nor can I oversee his homework, his bedtime or whether or not he's brushed his teeth. But he loves it. So it kind of turns into a little mini vacation for everyone.

But then you come around after a few days. And you make some broccoli and insist everyone eats it; you hide the Xbox controllers, and tell him (my son) he can't have them back until he brushes his teeth, cleans his room and changes his socks. And of course this doesn't go over so well, so you prepare for a battle. That's the hardest part – trying to get back the control you gave up.

But I don't do this all the time. Probably once a month at the most. And there are times where I know it's not worth the

Julie Blackmon
The Power of Now
40"x55"
Archival pigment print
2008
Courtesy of the artist

trade off. When your own kid is telling you he thinks maybe he should go to the dentist, or that he had to eat croutons for breakfast because he couldn't find anything else, I know I've gone too far.

So then I make the dentist appointments, go to the store, and try to tune back in. Sometimes that means listening to a 20-minute detailed retelling of a dream he had the night before, complete with kidnappers and police.

Unless I'm shooting, though, I can usually get a lot done while the kids are in school. Sending JPEGs, answering e-mails, sending invoices, etc. This is a different kind of work than what it takes to actually create. Many people don't realize this. I can never just sit right down and start creating, or pick up my camera and wing it without giving it a lot of thought first. There's always a period where I'm trying to forget everything else, so I can lose myself in creating something new. Sometimes the only place I can keep from being distracted is the car. So I'll turn my cell phone off, put on some good music and go for a drive. This is hard to explain to your family sometimes. My son wanted me to go and pick up his friend George the other day (there was no school for parent-teacher conferences) so he could come over and play. I told him no, that I was too busy, and that I had too much work to do. Well, I didn't realize I was being watched (I work from home). He monitored my every move that day, and at the end of the day he said, "Real hard day at work, Mom. You went on a drive, you went to get coffee, you listened to that freakin' Michael Bublé Christmas song like ten times. I even saw you getting on Facebook." And I didn't know what to say back because he was right. By all outward appearances, I was doing absolutely nothing.

Often, when I'm at one of my openings or at an art fair, people who are interested in my work always want to know where I'm from. They always seem a little surprised when I say Missouri. I usually don't even bother to tell them Springfield, Missouri, because just Missouri alone has them a little puzzled. I guess it's because most artists working today are usually living in larger metropolitan areas. And I think up until the last five to ten years, it was just a necessary part of the whole equation of becoming successful. But I don't think that's true anymore. I

have been working with six galleries around the United States, in cities such as Chicago, LA and New York, for several years now without a problem. And they've been selling my work around the world for some time. Really, any challenges to working with them have very little to do with my living where I do. But I guess it depends on who you ask. I occasionally get the idea that it's okay to be *from* a small town, but not *still live* in one. One of my friends even overheard one of my dealers telling a client at the gallery in Chicago that I am originally from Springfield, Missouri. And my friend (from my neighborhood at home) wanted to jump in and say, "No, no, she's not *originally* from Springfield, Missouri, she *is* from Springfield, Missouri."

In any case, I feel like living out my entire life so far in this one place has informed my work in a way that wouldn't be possible had I not. One of my early influences, Keith Carter, always tells his students that they don't have to travel far and wide to make art – they can find it in the most ordinary places. He learned a great deal through his friend and mentor, Horton Foote, the famous playwright, who would often speak about the importance of belonging to a particular place, and saying something about the times and culture you're a part of. For Foote, it was Wharton, Texas, and the lives of the people in that small town that he knew so well are what informed his work. For me, it's Springfield, Missouri. The work I've done for the past seven years has everything to do with this town and the people I know and love here.

But there are many challenges – location just doesn't seem to be one of them. Some of my most difficult days have less to do with finding inspiration around here or coming up with new ideas, but more to do with the day-to-day business aspect of what I do. I now have seven galleries. One in Zurich, and the other six are spread throughout the United States. If I'm lucky enough to come up with a new piece that seems like it might have some potential, instead of hearing from them about how much they like it, or why they like it, I'm all of a sudden getting e-mails like, "I need a large 'Night Movie' ASAP by Friday." It just feels a little harsh sometimes. Like you're pouring your heart and soul into your work, and turning out something that is very personal and close to you – and the next thing you know it's like you're a machine or running a sweatshop in your basement, printing

and packing and navigating what to send to whom, and if they're going to be mad that you can't send it "ASAP," because you already told another gallery they could show it at a certain art fair first. It can get crazy and overwhelming. And just because they're a gallery that's shown your work for years and you feel like you're close friends, you find out sometimes that it's what's in their own best interest that is their top priority. To them it's not personal, it's business. But for an artist, everything about their work is usually personal, and so even if it's not personal to them, it's personal to you. ●

Julie Heffernan
Self-Portrait as Big World
68"x70"
Oil on canvas
2008
Courtesy of the artist and
P.P.O.W. Gallery

I LEFT HOME AT 18 on the dot with nary a trust fund to my name, so I needed to learn early on how to survive with no help from parents or otherwise. My family is Catholic working-class that got its art from redeeming Blue Chip Stamps, and had one framed print of Jesus as the Sacred Heart on our living room wall. I worked my way through college at UCSC and took out loans to go to graduate school at Yale; after that I had to find ways pretty quickly to pay the rent, pay off those loans and support a painting life. I learned to be efficient. Speed and efficiency are my sports: if I can cook a square meal in a half hour rather than an hour, or drive to State College, PA, in four hours instead of the usual six, then I have an extra two-and-a-half hours to spend dreaming on my couch in the studio. I might have been an efficiency expert in another life.

My first jobs after grad school were working as a hack portrait painter, and for an interior decorator doing odd jobs (both of which I found through the yellow pages). The goal was to work three days a week making $200/day (this was in the 1980s); that way I could pay my rent and paint four days a week. No days off. I learned how to paint a portrait in about two hours, which meant on a good week I could think of myself as making $100/hour. Seemed like a good wage at the time.

After a year of that I decided enough was enough and applied for a Fulbright, to what was at the time West Berlin. I botched the application (I actually applied to the wrong institution), but

got the grant anyway, and in Berlin I had the time and space to indulge myself with 15-hour painting sessions in a dank hole of an apartment I sublet from a Goth guy who had blacked-out all the windows and kept fish in the toilet. There was only a wood-burning stove to heat the apartment, so my boyfriend and I would go out in a friend's car and scavenge wood from the streets. I got frostbite that winter.

When I got back from Berlin I got married to that boyfriend, then started in again with the decorative painting and learned some techniques that definitely helped me in my own work, so the hack work was not for naught. But after a few years of working atop high ladders and dangling from scaffolds, I decided I didn't want to be doing that kind of work when I turned 50, so I applied for a teaching job: a two-year position at Indiana University, Bloomington. I got the job, found out I loved teaching, and then got pregnant while running the Florence Drawing Program (pregnant by accident – it was Italy after all). Not wanting to ruin my just-budding career with a child, I was distraught to say the least; but I did some soul-searching and figured out I could do this – what at the time seemed crazy – thing, if I mustered all my resources.

That meant switching to a tenure-track job (at Penn State), finding a babysitting co-op in Brooklyn, where we lived, bringing one of my students from PA to live with us in our Brooklyn basement (with no toilet or running water) as an au pair girl (apparently it was worth it to be in NYC), and turning that same basement into a studio. We had bought a wreck of a house in 1992 which was, unbeknownst to us, the bottom of the housing market. (This was the biggest stroke of pure luck I can claim in my life.) I had just gotten an NEA and my husband Jonathan a full-time teaching job at Hunter College, and we had saved enough for a down payment, so we got our dilapidated house. I learned demolition and sheet rocking, and Jonathan learned to do electrical work, so we were able to renovate our house pretty much by ourselves, with the help of one overweight ex-con we met on the street.

The first chapters of making a painting life were very hard, and I had many ups and downs over the course of it (haven't we all?), some of which were accompanied by a poisonous fear of failure taking various forms – anxiety attacks, crying jags, like

that – but I learned how to knit myself back together, each time learning something deeper about myself and about making art that is true to oneself, and about the importance of not running after false, soul-deadening goals like coolness or the latest fad.

I've also had a lot of help in forms I might not have anticipated. My husband is a theater critic and has helped me immeasurably to improve my work and hone my ideas more closely. He has an uncanny way of pointing out a problem area in a painting, one I couldn't even see, and then giving me ideas for solving it, which I never use but which help me to see things from a different perspective. My kids also give me feedback despite themselves, by a process I call "inadvertent critique:" they come down to talk to me in the studio and, by either unconsciously gazing at the painting while chatting with me or ignoring it completely, I can tell whether the painting is too painful to look at or not. I think of unfinished paintings as wounded creatures that we avert our eyes from out of compassion or sheer avoidance of pain. If the kids look, it means the painting has composed itself.

And I've been in several artist groups where we take turns having studio visits and give each other unstinting critiques, with a real commitment to honesty – something hard to come by if not expressly requested. I've learned from teaching that we almost have to pay to get truly honest critiques.

I've been teaching at Montclair State University for 14 years and am now an Associate Professor. People ask me why I continue to teach now that I don't need to economically any more. The question always reminds me that teaching is a great boon because it forces us to come out of ourselves, and be constantly reminded, as we watch students go through the awkwardness and torture of those early jabs at self-expression, about the mini-miracle of self-transformation that art engenders (if we properly learn from its lessons). But, on a practical level, I'm also always aware that painting sales could dry up tomorrow if the economy really tanked or all the hedge fund guys were sent to hell in the Rapture; so, as the child of Depression-era parents, I keep my day job even after all these years.

I have a good relationship with my dealers, largely because I provide them with a lot of work and don't call them all the time. I don't want them to keep in constant contact with me because I'd prefer them to be in constant contact with curators

and collectors. I have learned over time that, at least in my case, when work doesn't do anything – get reviewed, get curated into shows or get sold – it's most likely the fault of the work, not the dealer. This isn't always true, but it's a good mantra to have because we really only have control over our work, not the art world.

I still work in that dank basement I renovated 19 years ago. I have two couches, each facing a painting wall. I laze on them, surround myself with tea and nuts like a Roman, and beam myself into whatever painting world I am currently in the midst of. If I'm lucky, the painting will play me and I rumba with it. I let it have the lead, and I follow madly, careering after it for as long as it lets me. ●

THE BIGGEST STRUGGLE throughout my life as an artist has been to put my studio time first. This doesn't always sit so well with the people in my life, but after 25 years I have managed to surround myself with those who accept this as a given in our relationship. When I stop to take a look at who is truly part of my life now, I realize that my closest friends and family are those people who understand my need to disengage, hunker down and become a bit of a recluse. These people never take it personally. It may sound harsh, but I have let go of some friendships and relationships over the years when they have been too demanding of my time and energy. My friends and I all share an ability to pick up where we left off, even if we haven't seen each other in months (or even years). This has made it easier to construct a life that is probably selfish at best.

Over the years I have slowly built up a teaching resume. After ten years of adjunct teaching at various institutions in NYC and waitressing part-time (a great skill to have by the way – flexible hours, cash at the end of the night, days free for studio, and most importantly, you don't "bring it home"), I decided I would try to get a full-time teaching job even if it meant relocating. Having never lived anywhere else but New York, I was intrigued with the idea of being in another part of the country and having a different experience. What I initially thought might be an experiment for one or two years ended up being a 13-year

Julie Langsam
Gropius Landscape (Director's Residence)
42"x42"
Oil on canvas
2012
Courtesy of the artist
Photography by Will Laughlin

adventure living and working in Cleveland, Ohio. My teaching schedule was three days a week, and as is typical, I had a month off in winter and three months off in summer. This allowed me ample studio time, and it was one of my most creative and productive periods. I had my first museum show, and got gallery representation in NYC. In addition to teaching and exhibiting, I began to curate exhibitions of other artists' work and create and develop arts programming around issues I was interested in; and this in turn fed my studio practice. Living in the Midwest I came to really understand that there are other "art worlds" out there, other communities, other venues and other like-minded people. I am now living and teaching again in New York, but the experience of living in a city outside the "center of gravity" was extremely valuable.

For me, the studio is for *working*: painting, drawing, developing ideas. I try to allocate three to four studio days a week. For me, this means nothing else is scheduled on those days. I like to settle down and work for eight hours uninterrupted, so I tend not to answer the phone, I don't usually bring my computer with me, and I don't go out to eat or run errands. I try to limit as many outside distractions as possible. I work with an assistant who does a lot of the "paperwork" – documentation, keeping the website, correspondence, etc., up to date. My assistant also prepares canvases for me and does framing and other related tasks, but I don't have anyone who actually works on my paintings. I have learned to work with my assistant in the studio, but I prefer to be alone without any interruptions, so whenever it's possible, my assistant works when I am not there. Research and writing I mostly do outside of the studio in a small office space at home. I find this keeps me focused; when I am working on a painting I am not distracted by the presence of the computer, and when I am writing or doing research I am not itching to pick up a brush.

The way that I have found to balance art/life is to try to maintain an equilibrium between social space and solitary space. I need a lot of solitary space both to work and to just "be." My partner understands this, and it actually works out well that we live in different cities. This solitary space is balanced by both teaching, which is interactive and social, and by the shared

aspects of the art world, such as openings, lectures and other community events.

I have worked with several dealers over the years; I value each of these relationships, and have learned different things from each of these experiences about both the business and myself. I believe in each instance we have been productive as a team, but it has always been a collaborative effort. I have not had the experience of working with a high-profile gallerist, so I have always felt that ultimately it is up to me to make things happen. This leaves me pleasantly surprised when opportunities come my way that I have not sought out, but it is the exception rather than the rule. Although I am never quite comfortable in situations where I have to advocate for myself or my work, I have gotten better at that part of the job of being an artist. There is something to be said for the "fire in the belly" of youth, but I wouldn't trade it for the certainty I feel today about my choices, my practice, my life, that have only come with time. For me, in the end it is the everyday-ness of the studio practice that yields work that has significance and a life that has meaning. ●

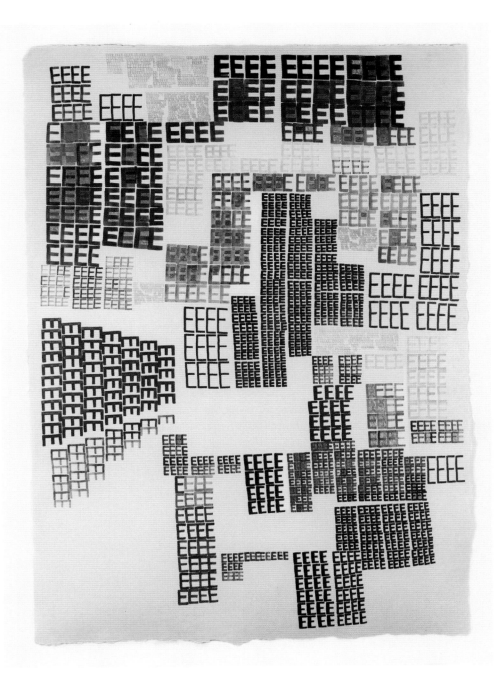

I SOMETIMES FANTASIZE about having an art career where my warehouse-sized studio is jammed with finished pieces. I'm talking about a high-powered Takashi Murakami kind of existence, where assistants grapple with difficult problems, and my most pressing issue is curating a new show from the mammoth piles of work held in climate-controlled storage units. Well, maybe this isn't really a *dream* of mine, but the idea seems cool, and I think about having this rock star lifestyle in the same way that I think about having won the lottery. The fact is that my art career is so different from this fantasy that it's almost funny: mine is so rural, modest and normal… but it's what I have and it's sustainable, and I'm totally into it.

I spent five years in graduate school, getting an MFA in printmaking, an MA in art history and a certificate in book studies. I thought this diverse training would help me land a position as a generalist, but damned if I didn't get a specialist printmaking position in Dallas. But, after three kids and five years of teaching, the time had come to return to the upper Midwest. Degrees, experience and a rigorous exhibition schedule paid off, and I was offered a position close to my family.

Everything starts at home. My wife and I live in a small Minnesota city about an hour from Minneapolis, and our set-up is pretty ideal. I teach full-time at a university that is in reach by foot or canoe, and having grown up in the general area, we thrive

Justin Quinn
Short Words with Tower
48"x34"
Ink and graphite on paper
2012
Courtesy of the artist
Photography by Peter Happel Christian

on the edge of both civilization and wilderness. Our semi-rural existence means being able to afford a yard and a modest studio downtown, where I can stare at my work for hours on end.

Home, university and studio are all within walking distance from each other. There is fluidity between the spaces; I make art at all three places, and approach the work in a slightly different way depending on where I am. I rarely work at home, but have an old postal desk, a family heirloom, that serves as a great standing-height drafting table. During summer breaks, I'll sometimes have a small drawing going that gets a little attention now and then – great for lazy days but not ideal for uninterrupted sessions. My university print shop is amazing. This huge space overlooks the Mississippi River, and is fully equipped for lithography, screen and etching. I get as much work done during teaching hours as I can reasonably accomplish, usually publishing a few print editions each year along with some drawings that are perpetually in progress on a back table. The bulk of my work is, however, completed in my spartan two-room studio. Here I have a large drawing table, flat files, a couch and stereo. I spend as many of my non-teaching days here as possible.

In contrast to my art-star fantasy, my production is steady but modest, with a typical year seeing only a couple dozen new pieces. The work is modest as well, mostly works on paper that go from studio table to studio wall, and then from photographer to gallery. Because I work slowly on each piece, I often feel like I'm behind the eight ball getting bodies of work done in time for scheduled exhibitions. True, there just aren't enough hours in the day to do everything that I want to do, but I manage and try to keep up a reasonable balance between studio and home. I do have rules that help – like only working during daylight hours and very rarely on weekends. These rules are based on aesthetics, and making my professional life comfortable naturally leads to that life being sustainable.

The fact is, between home, work and studio time, I'm able to carve out a very productive creative life, and sustaining this life is key. Each component – family, teaching and creating – works to keep the other parts going. My research and teaching

inform my studio practice just as my professional life enriches my teaching. Family time and time spent away from art-making allow my studio experience to be more focused, essential and creative. I am compelled to work in the studio and sometimes have very little choice (as deadlines are excellent motivators). But I have learned that, for me, sustaining a creative life means that life has to be nourished first. Creativity follows sustenance. •

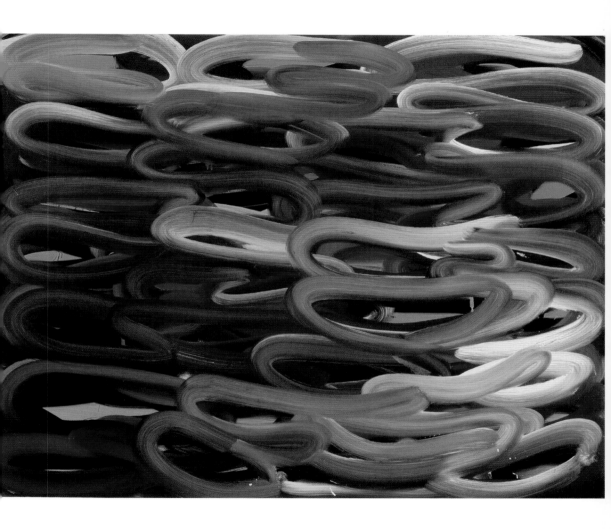

MANY TIMES OVER the years I've thought to myself: "What would I be if I wasn't an artist or wasn't able to be an artist?" Every time, I came back to the answer that there's nothing else I would want to do or could be. I have fantasies about being a different type of artist like a dancer or actor sometimes, or would like to expand my artistic practice by working with a specific designer to do a special project, but everything always revolves around making art. Most of the artists I've ever spoken to have said the same thing – that's it's not a choice; it's something that chooses you.

When I was younger and first in NYC after graduate school, I think I took being an artist for granted. It felt so *normal* in a city like NYC. I never saw it as something that was different or special. I didn't think of it as my *gift* that obligated me to give back to the world. I saw it as a vocation that I chose to make into a profession that I truly loved and needed to make my life alive and purposeful.

After graduate school at Rhode Island School of Design (RISD) in Rhode Island, I came directly to New York to a work as a studio assistant. I knew very few people in NYC, and it was my first time in the real world trying to be financially self-sufficient and an artist. I lived in a small apartment in Williamsburg (Henry Miller's childhood house), because it was more affordable and a developing art community. Later, I

Karin Davie
Symptomania no 1
Part of the *Symptomania* series
66"x84"
Oil on linen
2008
Courtesy of the artist

lived in the Italian part of Williamsburg. Every day after work I would come home and go straight into my studio – a small room in my apartment. During this time, I made various sculptures instead of painting, and one example was a wall of bricks made out of crushed leaves collected from a nearby cemetery. As an installation in my studio, I accidently bricked myself into my apartment with the bricks (perhaps a symbolic act)! On the one hand, I felt lucky to have a job as an artist assistant; at least I had a job and thought I was doing something creative. On the other hand, it offered me little in the way of emotional/psychic space or creative time to develop my own art. After several years of this type of work, I stopped, feeling physically drained from the experience, but also hopeful. It took some time to recover, but gave me great insight and clarity into the daily life of a "professional" artist.

There have been many spectacular moments in my career that stand out as highlights and of which I feel proud. I've had the opportunity to exhibit in many parts of the world in progressive venues, and the privilege of working with some inspiring, committed people whom I admire. But I've also had some very challenging periods in my life, both personally and professionally, where for various reasons it was impossible to make the art that I had envisioned. At one point, I was so broke that I decided to go out onto the street to sell some handmade scarves that I made in order to pay the rent – only to be discovered by a young art dealer who was shocked to see me there!

Throughout the early part of my career, when I began showing regularly in commercial galleries, I had many part-time forms of employment to supplement my income from art sales. One of these included working in a vintage clothing store, being a visiting artist, teaching art in NYC community centers to adults, seniors and people with mental illnesses, and teaching art students at Columbia University.

Sometimes the stresses of trying to balance the practical aspects of normal life with personal relationships and the commitment to art-making takes it tolls on your creativity. I clearly remember a time back in the late 1990s when I had what

I call a year-long "painter's block." I found myself painting and repainting and looking at what I had done after every session and thinking to myself, "Why doesn't it look like the doodles I make of that same image – what's missing?" After two years of searching for the image, it suddenly occurred to me that there was a very simple answer for the difference between the doodle and its painted version, and it had to do with the scale. The point being that the answer was as simple as making a slight technical shift and was right in front of me all along. I often reflect back on this period of time as it serves as a good metaphor for all other periods of change that has occurred in my life. Even during the most difficult times, I never stopped making some type of work or dreaming of things to come – even if it meant only being able to make small doodles in my sketchbook. But I've also had the good fortune to receive outside financial support at important times; from various institutions in the form of awards and grants, sales from galleries, as well as receiving help from my supportive parents.

A few years ago, I felt a deep need for a change of environment. I had lived in NYC for the last 23 years without much of a break. I missed being surrounded by nature and the smell of clean ozonated air. Although I was born and raised in Toronto, our family life gravitated between the city and a small rural town north of Toronto near the water, so I've always felt a little bit country and a little bit urban. So I decided to make a change, and temporarily move to the Northwest coast closer to my family. I have two art studios and two apartments both in NYC and Seattle. I have two part-time assistants who help me navigate the practical aspects of living in two places, making artwork and doing exhibitions. At times it's complicated, but it's also been an immensely gratifying experience. It's allowed me the psychic space to think differently about my creative process. I've also benefited from not thinking that there's a prescriptive way to live one's life as an artist. Like everything else, it's about one's own invention. With the Internet and other tools for social networking, there are multiple ways which I've used to facilitate doing business and staying connected to art markets and communities all over the world.

I've always felt the need to challenge myself and not be afraid to take risks in order to stay deeply connected to the artistic

process. It's a way to sort through what's truly meaningful. In looking back, I realize there have been several distinct periods in my life of reflection followed by a reinvention, and all of these periods have led to transformation. Making art depends on taking leaps of faith, but I always try to stay true to what is absolutely necessary to feed my soul and artistic practice. •

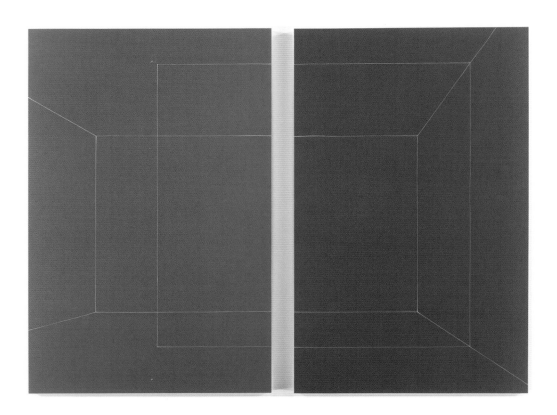

HOW IS MY practice supported... what does support mean?

Collaboration, technical assistance, being "kept company," spiritual renewal, financial partnership, a social trampoline, another eye, my mother! I have been blessed by many relationships, the most supportive of which is with my "right-hand man" (female) assistant, with whom I have worked for 11 years now. I first asked her to come help in the studio when I was pregnant and she was the cashier at Mama's in the East Village. I would leave her hard-to-read notes of tasks to do in the evening after I left. This odd exchange evolved into a long-lasting relationship; we are still working and even traveling together. She does a lot of the "doing" work but is also involved in the decision-making process. What's most important is that she remembers conversations from years ago. This week I retrieved a photo which I hoped to use for a wooden puzzle work, and she replayed a discussion about it that we had had two years ago.

We sit at the desk three or four times a week going over the ideas, photos, sketches, illustrator and sketch-up files I have accumulated. Together we edit my instructional or technical e-mails for clarity. She prepares panel surfaces, does inventory, bookkeeping, and shares her opinions about work while it is in process. She is informed about the world at large; I would rather talk politics with her than with anyone else. While I would like an "office manager," I do all the e-mail correspondence in the studio, which can take more than half of the focus time. Rarely

Kate Shepherd
Respite from all News, All Grey
39 ¾"x25 ½", 39 ¾"x24 ½", (2 ¼" gap)
Oil on panels
2003
Courtesy of the artist and Galerie Lelong

does anyone else speak on my behalf, as I like to be the one who cultivates relationships and oversees details. This is not ideal...

I've gotten technical help with drawing. Starting in 2002, when I began to use more complicated imagery that I could construct with a thread-based perspective system, I worked with an architect. The first impetus for doing so was to make a painting based on a Caucasian rug. We started to work based on my sketches, and then moved on to building ideas directly on the computer. I have had a longest and most meaningful working relationship with a man who moved home to Palestine, so for the last five years we have had a back and forth using e-mail, iChat and screen-sharing. He has taught me how to use various programs and their keyboard shortcuts, and has even inadvertently chosen colors for paintings by showing me a rendering that just sticks in my head.

With his help, I also make files to send to a screen printer with whom I make editions, drawing surfaces and monoprints. I have worked closely with the same printer for 12 years; he is a better colorist than I am (!). There is less and less pre-planning in my work these days, and I enjoy how the input of all the printers in his shop can bend a project.

From two ex-assistants who are really smart and creative problem-solver artists, I have sought carpentry and logistical help. We are each other's teachers. One has fine skills in fabrication and installation, exhibiting an intense respect for craft and workmanship; he has taught me about specific use of fastening systems, hardware and tools. With the other, I have discussed architectural perspective and techniques for wall paintings, and we have built countless things with great efficiency. Every time I move studios, we take apart the shelving wood and reconstruct it to accommodate the new space. I get a huge kick out of working upwards from the size of the materials.

My dealers: I tend to work with people who are sympathetic yet business-minded, with whom I have an honest and frank exchange. Showing and selling art is about promoting ideas, and in the best of worlds there is a sensitive understanding that goes two ways. I have recently branched off from making solely paintings, and so these relationships have been crucial in bringing new work forward.

My husband and I are supportive of one another's work lives, and, to other people, we appear to have an unconventional marriage, as they have never seen him! I socialize and attend openings on my own, as well as travel for shows and research. He is very trusting of me, and shares a tendency to focus intensively on work (he has a particularly demanding job). We value our time together at home with our son, and have pretty much gotten along without a sitter while splitting childcare. We have found help: when our son was a baby, he was in day care, then later he stayed for after-school, and now that he is older he takes care of himself more. By having a family, I often feel like I live a double life and am in two places at once, which is very stressful, but it's worth it.

Art is like an abstract run-on religion in and of itself, yet I also have a deep need for metaphysical interpretation from other sources and disciplines. I have found teachers of metaphysics and words and music from the Christian Science Hymnal to be particularly resonant. I spend subway time for reading, sometimes taking the train to the end of the line and back if I want to read more of the *New York Times*. Oftentimes, my focus is on an analysis of language and on the structure of ideas that are parallel to how I think about art work.

Having a good place to get bread is terrifically helpful; most days I eat a cheese or avocado sandwich without stopping work. Because I have a child, my day in the studio ends at dinner time. I make no appointments during the day and my best working hours are between 2 and 6 p.m. When there's an event to attend in the evening, I don't go home to change first; I wear pretty much the same outfit every day! (Thank you Italian tailor for the identical shirts, and thank you Uniqlo for everything else.) Every Monday, a woman comes to the apartment and does the wash....The super's helper mops my studio floors every other week, and these are true luxuries. I especially appreciate any help with cleaning...!

In creative terms, I am invigorated by collaboration; maybe this tendency has something to do with my theater family (my father was a pioneer of political improvisation theater, and my mother is an actress and director). As my work revolves around

conceptual structures that are game-like, I constantly "volley" via the US Postal Service and e-mail. Playing makes me immensely happy and helps me to trust my instincts. To one of my dealers, I sent magazine clippings with captions and he made a book from them. Recently, I wanted to send a pencil to a friend who is particularly fun, and after three tries it reached him unbroken. A Swiss artist and I have been sending each other objects from cast-off materials that serve as unrelated props for an ongoing story. And with artists down the street from my studio, we trade half-made works on paper for the other person to finish. I would not be as happy or productive without the exchanges I have with my friends.

In the studio, I make an effort to execute new ideas before explaining them away, so as not to lose momentum and a personal connection to the process. Afterwards, I try to avoid "storytelling" in the hope and belief that the work can speak for itself. I try to speak about my work honestly, which is hard to do because by the time the work is done, I have forgotten a lot. Essentially, the response of the viewer (friend, dealer, collector) is the last element of "support," which helps me to understand the effectiveness of my expression and intention. Without talking about it, I watch people while they look at my work, and their immediate response is palpable to me. This truly helps me to know if I am bringing an idea to fruition, while also heightening my self-awareness. ●

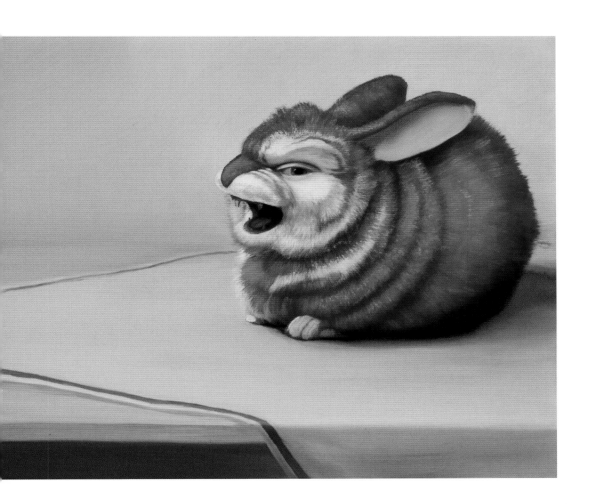

I'M A HARDCORE night dweller. All through my student years, and as a young, single artist unencumbered by family and job responsibilities and their attendant schedules, I worked late into the night, every night. I see my students, the dedicated ones anyway, displaying the same behaviors when I'm up that late.

The fact of my nocturnal nature is not helpful now, but it is sort of emblematic of the organizing conditions of my adult life as an artist, professor and mother. This is because these roles demand that I function like the other sole proprietors, workers and moms – roughly from 5:30 a.m. until such time as a combination of exercise-induced physical exhaustion, mint tea, reading, television or the occasional Xanax conspire to shut down my racing brain. There seems an inherent contradiction between the linear activities required by the business of art, and the meandering, peripatetic, insight-oriented practice of creative work.

All this is salient to the essential task of sustaining my studio practice: staying engaged with my creative process, managing the material and time requirements and making a living, and living in a way that bears some semblance to what I consider a satisfying, socially-engaged life. This, for me, requires a conscious effort towards efficiency. It seems impossible, or at least contradictory: how does one apply principles of efficient production when the product represents processes that are not always conscious, and result from non-tendentious play,

Laurie Hogin
Home Fires #11 (Just What Is It That Makes Today's Homes So Different, So Appealing?)
12"x10"
Oil on panel
2011
Courtesy of the artist and Koplin Del Rio Gallery
Photography by Greg Boozell

research and associative thinking? My work takes a long time to execute, and that is something that can only take place in my studio. This requires that even when what I'm doing seems unrelated to my studio work, I'm open to whatever stimulus – be it intellectualized or sensory – might filter through my creative process into my art-making.

Efficiency in my practice means that I engage in willful awareness that my work is not simply a product of consciously directed, linear intellectual work, where there is a one-to-one relationship between the effort I make and the result, as there is with accounting or washing dishes. It's a product of the whole animal, and I work more creatively, with better ideas, greater inspiration and energy, when I don't compartmentalize my life. My teaching – with the often exciting, passionate, interesting discussions with my students – and my relationships with my husband, son, friends and colleagues are all parts of my day, but I allow the consistencies to exist, and the essences of each set of experiences to inform the others. I like to think, to converse with myself, to ponder traumas, pleasures, problems and the topics of the day during the extensive alone time I require to maintain well-being. I do much of my creative intellectual work while running, biking and driving (which I love); talking, listening and reading, researching; building and racing slot cars; looking, thinking, feeling, and navigating the bizarre landscapes of consumer capitalism. I derive a sense of my subject matter from these activities, which begins to take form before I'm even in my studio. In fact, much of my work is quite done in my head when I walk through my studio door, though I remain open to editing, revising, and even reneging, when the material process demands it.

It helps to make my studio practice convenient. All my books, papers, supplies, materials, tools, pictures, communication devices, notebooks and reference materials are in my studio space. My truck, an old Ram beater with an 8 ft. bed, is outside the studio door, ready to bring lumber in and deliver finished work to galleries or shippers. I even have a place to sleep in my studio, and my studio is in my home, where everything else necessary to my day-to-day life, including spouse and child,

abide. All these are investments, both tangible property and intangible conditions, that enhance my productivity.

I'm in my studio mostly to manufacture – to execute the material tasks necessary to the existence of the objects that constitute my work, and conduct the business aspects of the profession, including correspondence with gallerists, curators, collectors, writers, and others with whom I share an interest in showing, selling or discussing my work. These tasks also include things like packaging artworks for shipping, preparing canvases and panels for painting, writing press releases and artist's statements, keeping records for tax purposes, and vacuuming dog hair off the rug and furniture before it has a chance to migrate to the surface of my works in progress. At times, I have had assistants do much of this, but I'm too obsessive about the painting surfaces and too haphazard and idiosyncratic about my filing systems – and too invested in my solitude – to have much hired help.

It helps, too, that my gallerists deal with almost all aspects of selling work to collectors, and much of the work of representing it, literally and physically, as well as conceptually and thematically, to the various art worlds made up of curators, writers, critics and other artists.

My relationships with gallerists are productive and good. They tell me it's helpful that I understand that our economic interests are linked, and try to be supportive of their positions and understanding of their points of view. Occasionally, my interest in making work I care about, and the galleries' interest in selling the work, or otherwise capitalizing on its value as a commodity, seem at odds. This is kind of an illusion, and true only in the short term. My work only seems valuable beyond my own solipsistic pleasure, when it garners the attention of people who indicate by their response that my work makes meaning for them, that they relate to it, or feel it speaks to them, or helps them represent their own subjecthood. They do this by talking about it, writing about it, curating it into exhibitions, photographing and reproducing it, and owning it. My gallerists have an interest in seeing this happen, and I do what I can to support them. I deliver what I say I will, on time, and maintain

an above-board, honest communication. Besides, I like almost all of them very much.

Living in a small town, my friends and social support networks are made up of my kid's friends' parents, members of the PTO, teachers, school principals, neighbors, local activists, and people who go to the gym in town. Here I've been able to pursue a research interest in community-based art, as well as cultural practices that resemble art and represent untrained or unofficial models of creativity (such as model-making, taxidermy and diorama craft), and art-centered and visually-based educational strategies. All these interests help me accommodate a wide variety of research interests, cultural backgrounds and aspirations in my students. These interests also reflect a commitment to the social value of creativity at the highest levels of fine art practices in such places as museums, galleries and art academies, in innovative design practices, and also in public schools, which I consider essential and an important professional destination for our best and brightest.

In 2008, I was able to get a small research grant to create a visually-based nutrition education program for elementary schoolchildren, and was fortunate enough to be working with a principal whose attitude was inclusive, if not visionary; when it came to ways to make his school stand out, he was, and remains, open to all possibilities. He welcomed my participation and gave me free rein, which is rare and tremendously helpful. The project includes a permanent 28 ft. mural and educational comics that are the basis for a healthy eating curriculum for first- and second- graders. Both the mural and the comics are used daily as teaching tools. The program's strategies dovetail with the joyful, child-centered culture of the school itself, and enhance visual experience there, resulting in an environment in which young brains have a chance to wire memories of fun and broccoli in the same experience. Our town is racially fairly homogeneous, but there is significant economic disparity and cultural difference between the cosmopolitanism of those associated with the university, wealthy industrial farmers, and those whose backgrounds include rural isolation and poverty. This work had significant, beneficial outcomes, both in terms of its usefulness in the community and the way it led me to develop

new skills (the ability to paint giant still lifes), and new ways to understand the potentials of my art practice. Food imagery and food metaphors began to show up more frequently in my studio work, too.

At the end of the day, literally and proverbially, the answer to the difficulties of sustaining my creative life lies in my fierce motivation to do so. The origin of this motivation is mostly a mystery to me, and probably has something to do with the way we human primates depend on memory and narrative to construct a sense of self and of the world, but rather than ponder that, I just admit that I get bored easily, I don't put much stock in prestige, and I like to learn. There's a slot car racing club in the town where I teach. Guys from all over the region go there on Thursday nights to race. I'm the only female member. I'm also probably the only one who's contemplating the meaning these grown men and I invest in these tiny cars and miniature landscapes, but no one cares. It resembles art, but no one cares about that either. Like my trail running in the woods, reading of critical theory, viewing of contemporary art, collecting, teaching, talking to friends and colleagues, raising a child and everything else, it enhances my knowledge, piques my curiosity, feeds my brain and gives me topics that keep me going. •

MAGGIE: AT THE risk of sounding like an organization, Dan and I keep spoken and unspoken schedules while we maintain relationship structures and roles. Our day-to-day life functions by sharing, dividing, conquering – whether raising our child, working in our studios, teaching, cooking, doing laundry, grocery shopping, parking the car, etc.

We met as students in 1992, during our BFA programs. I was a freshman at the University of Wisconsin, Milwaukee (UWM), and Dan was a junior at The Milwaukee Institute of Art and Design (MIAD). Dan offered me a ride home from a mutual friend's apartment where we listened to a John Cage recording. It was the first time I had heard his work, but my head spun for more than one reason that night. Dan and I talked for hours, and we exchanged numbers on the plush seat of his Oldsmobile. (This occurred back when landlines were the only phones and voicemail was received on audio tape.)

As it happened, it was mutually beneficial that we were enrolled in different BFA programs. We compared our experiences at UWM and MIAD, and contrasted their respective professors and students. We talked about what we were learning, and because we shared everything, we enriched one another's education – our two schools were remarkably different. Unofficially, I became Dan's model for his academic figure painting. I was more than happy to sit still for him for hours while I read art history, mythology and philosophy

Maggie Michael
Swans of Other Worlds: Open/
Closure
50"x40"
Ink, latex, enamel, spray paint
on canvas
2012
Courtesy of the artist
Photography by Dan Steinhilber

textbooks, with the smell of linseed oil in the air. It was romantic and real at the same time. Being in two schools and working together created a professional intimacy, and yet we maintained our individuality – that was an optimal model for us. We have continued this practice today, and benefit from having our studios in separate places, because living *and* working together might give us too many of the same experiences.

Falling in love was easy. What became labored was managing our bank account after college (when our student loans came due). Artists often partner with someone who has a reliable career and income, but we would not change partners now or in hindsight. The timing of an art sale is anyone's guess when a piece will actually find an owner. At some moments, the sales are plentiful, while at other times they are missing in action for long periods of time. Grants and awards are important and wonderful. When we finished graduate school at American University in 2002, we were both beginning to show our work in artist-run spaces and commercial galleries. When we needed it the most, the Joan Mitchell Foundation Painters and Sculptors Grants carried us (and our newborn) for two years.

Beyond grants, awards and art sales, I (more than Dan) need to have the certainty of an income in order to function well in the studio. When Dan and I lived in California after college, we both taught in public schools as substitute teachers. At the time, anyone with any bachelor's degree could be a substitute teacher for any class. Dan taught everything from math, science, special education, physical education and kindergarten. I taught art and multiple subjects. After a couple years of this, Dan took a job as a sculptor's assistant, and I continued teaching, learning and working toward an MA in education from San Francisco State University. Currently, I teach art part-time to kindergartners and first-graders at an independent K-12 school in Washington, D.C., where our son also attends. Additionally, for one or two semesters each year, I teach a class at The Corcoran College of Art and Design or American University. I enjoy the mental stimulation of preparing a syllabus, lesson plans (propositions) and interacting with students. On the days I don't teach, I go to the studio and Dan drives our son to school. Dan sometimes

Dan Steinhilber
Marlin Underground (concept sketch)
Dimensions variable
2012
Courtesy of the artist

teaches a class or two at local universities, but usually he works in the studio full-time because he is preparing for a museum exhibition or working on a commission. When I receive a mural commission, I enjoy working on-site and with people. If I receive a commission for a work on canvas, I make three paintings at once (of a certain size) so the collectors can select one of them in my studio. In this situation, I am confident to work and not worry if the new painting I am making is "the one" collectors will want; chances are they will like one, two or all three of them. It is exciting to create a situation of choice both in the process and selection. While a commission begins as a situation of trust and precise dimensions, more interestingly, it is a situation of possibility and potential. This is my favorite way of working because it is intimate in conversation, expectation and surprise.

DAN: A typical day for me often goes like this: I take our son Clay to school in the morning and go to work at my studio until 5 p.m. I pick Clay up from school, go home, and make dinner for the family. Maggie and I enjoy raising Clay and sharing the responsibilities of parenthood. Some evenings, after Clay has gone to bed, I do a few tasks on the computer or make drawings. Often, Maggie or I will return to the studio for a late-night session. Over the years, we have persisted at this rhythm between life as a family and life as artists.

As artists developing separate practices and while being married since 1996 (when I was 24 years old and Maggie was 22), Maggie and I have basically grown into adulthood together. Over time we learned how to help, support and appreciate each other rather than to be competitive. For example, on days when Maggie is teaching, I often go to her studio and do practical things for her – build stretchers, prime canvases, and keep her supplies organized so that her time in the studio can be focused on painting.

Working alone in the studio, I follow many tangents and look for surprises. Often a day of work will only produce new problems and messes. Maggie is good at pointing out potential in a new process or idea and, conversely, when she sees that

something looks like a waste of time. We can give each other tactful, long-winded critiques, and we can be honest, *sans* frills.

Much of our social life outside the studios and our home revolves around our role as members of the arts community. It feels like we are constantly attending events, dinners, lectures openings, parties, etc. It seems that social relationships are often the currency in this field as much as the work you do. I would likely choose to stay involved with my own projects as Maggie refocuses my attention on the need for social involvement. Clay was born ten years ago, and we have spent a lot of money on caregivers for these purposes; yet, we have also taken Clay with us just as often. In fact, Clay was in museums and at parties with us from the beginning, and was naturally charming or sleeping through the entire event. Many people seem to give us extra credit because we involve our child in our life as artists. Clay has excellent conversational skills, yet he does not make a great deal of artworks. Nevertheless, he is imaginative and creative and amazing to us.

Making a living as an artist is not easy. While I do not yet have a gallery that represents my work in New York, London, Berlin or LA, I am fortunate to have representation, exhibitions and sales through G Fine Art in Washington, D.C. I am very grateful to museums and curators who have supported my projects over the years. Occasionally, a public art project comes my way. Truth be told, there are many issues beyond an artist's control that makes such a process become drawn out, and on a few occasions public or corporate projects end for a variety of external reasons before ground is even broken. In these situations, when it is appropriate, I ask for reimbursements for time and materials. I keep track of expenses for each project. The credit card is a nice tool, but spending our income becomes too easy with large amounts of credit. The best financial decision Maggie and I ever made was to buy our condo in downtown Washington, D.C. during a special affordable housing program for artists through the Culture Development Corporation (CuDC).

Someday, Maggie and I would like to own our own studio spaces. We pay relatively high rent for studio spaces in

Washington, D.C., and we wish that we had been able to afford to buy a studio space as well. Renting two studios is a big expense and an unstable reality for us. For a variety of reasons, one of us is forced to move studios every few years. We always find a new space because we ask friends and other artists for help in the hunt. The reason we have stayed in Washington, D.C., as long as we have is due to our studios, friends, collectors, and our son's fabulous school. Maggie and I both get a lot of work done here, and really enjoy the many museums and public programming. •

THE COLLECTIVE THAT calls itself "What How and For Whom" (WHW) curated the 2009 Istanbul Biennial, titling their show "What Keeps Mankind Alive?", a song from Brecht's *Threepenny Opera*. "Mankind is kept alive by bestial acts" is the song's retort. First performed in Berlin in 1928, in the midst of a another financial crisis, there is no doubt that the bestial acts referred to are the same as those of today's 1% – behavior that allows a few to sustain great wealth through the poverty of the majority. As I see it, this is also the way the art market works: a hierarchical structure in which only a limited number of artists achieve any lasting recognition, usually with their work acquiring tremendous value, while other less recognized art workers exist at the margins.

For me, sustainability is twofold: the necessities, food, clothing, shelter, medical care – what Brecht calls "the basic food position" and the desire and need to keep going… to keep working. While the "bestial acts" in question are admittedly less dire than those pushing the formerly middle-class closer and closer to the poverty line, they do result in the inadequate support available to most contemporary practitioners, including not just monetary compensation, but all the factors that contribute to the legitimization of an artist. And the needs of the ego for support and recognition can be just as rapacious as the body's demands for nutrition, but often with more limited access to satisfaction. It has always been a delicate balance.

Maureen Connor
Linens
Dimensions variable
Organdy
1980
Courtesy of the artist

While I've certainly had some luck in my life, I don't consider myself particularly lucky. I don't win raffles or other contests based on random selection. I've never been interested in forms of gambling like poker. Yet I've often been drawn to working methods in which chance operations, improvisation and working blind have been central to the success of the outcome. Sometimes I enjoy being unprepared, thrilled by making things up as I go; improvising, performing mental, as well as physical, bricolage. This was driven early on by my interest in Dada and Surrealism, and led me to performance and to eventually Fluxus via my contact with Alison Knowles and Dick Higgins (I rented space from them). I was also fortunate to work with Jean Dupuy, a wonderful, generous artist who continued to develop the Fluxus "economy" after George Maciunas died, holding events in his SoHo loft that included many young artists and drew large audiences. (In retrospect, however, my compulsion to work with chance was also an unconscious acknowledgment, as well as an enactment of a sense, of how the universe operates.)

Yet, in terms of "the basic food position," I've been pretty risk averse. I got married very young – a very conventional thing to do in the early 1970s – and I started teaching right out of grad school, in a private high school – also a safe choice. I had to get up early, which meant not much time for partying or hanging out, nor did it pay me well enough to do so. But in terms of sustaining my desire to make art, I have taken a somewhat unusual path.

Starting in the early 1970s, I became active in the feminist art movement. I participated in a number of shows that were defined as feminist, and began to actively explore the idea of "female experience" in my work. From the beginning, I received a lot of support from my feminist friends and colleagues. The impact of feminism was also one of many factors that led to my divorce in 1976. Probably not so coincidentally, my parents also divorced around the same time, and sold the house I grew up in. When I heard my father was going to have a yard sale to get rid of everything in the attic, I couldn't bear the thought of my mother's cocktail and evening dresses, as well as the smocked dresses my grandmother had made for my sister and me, being dispersed among strangers. So I asked him to send me everything. By then I had found a loft in Tribeca (very

inexpensive at the time, especially compared to current prices), so I thought I had adequate space. However, once everything arrived I was all but compelled to use the clothing in my work, as much a way to deal with the storage problem they created as to address the memories they evoked. I had always been interested in clothes, and for a time had thought about designing them, so once I began to use clothing in my work, I found more and more areas of exploration, some that would engage me for decades.

Most of the artists I knew lived very marginally, and although my part-time teaching salary was low, I was one of the few with a regular job, and it kind of embarrassed me, somehow reducing my credibility (and making the impulse to keep working that much stronger). Also, I didn't like teaching high school, and kept exploring other ways to make money, doing costumes for theatrical productions and fashion photo styling. Through the mentoring of then editor of *Artforum*, Joseph Masheck, I wrote several articles exploring the connections between fashion, historical textiles and contemporary art, and also reviewed some exhibitions. Doing the latter showed me I didn't have the heart – or maybe I had too much – to become an artist/critic.

The first adjunct position I was offered was teaching Fashion History at the Wood Tobé-Coburn School for Fashion Careers. Founded in 1937 as a kind of fashion-oriented women's finishing school, by the late 1970s its students were a challenging co-ed mix. I had already been researching the history of fashion out of my own curiosity and also for writing projects, but not in a very systemic way, so I stayed one class ahead of my students the first time around. After several years, I started teaching Parsons Fashion students, and once my foot was in the door there, I was able to convince the administration I should also teach some sculpture courses and MFA seminars as well, and slowly expanded my reach to Rhode Island School of Design (RISD), Princeton, School of Visual Arts (SVA) and Brooklyn College. All of this took care of "the basic food position," but not much more.

In 1980 I had my first one-person show in a commercial New York gallery, Acquavella – a "modern masters" showcase that had a "contemporary" department until 1985. The gallery director had seen my work in several group shows, and through mutual friends I "heard" he had some interest, so I wrote him a

note (17 years before widespread e-mail use), and his response was to suggest I make a proposal. Although Acquavella, founded in 1921, wasn't exactly a hip venue for contemporary art, it was a venerable site with a beautiful space: located in a circa 1910 neoclassical building on East 79th Street, with original interior molding, paneling, ceilings and elegant marble floors and fireplaces still intact. Using this Edwardian ambience as the point of departure, I proposed an installation based on seventeenth- to nineteenth-century napkin and tablecloth folding. I discovered the original techniques while doing research for my fashion history classes, but played with them, making hybrids of different folds and making them quite large; the largest was 7 ft. – almost monstrous. The show got a lot of positive press, and many of the critics were women who focused on the gender-based domestic disruption that was my subtext. However, only one review, by William Zimmer, written for the long-defunct *Soho News*, really captured the class boundaries I was pushing in that installation: I was making reference to the original upper-class domestic uses that were part of the history of the space, and the unceasing labor it took to keep everything running smoothly in that world. It took me quite some time to understand why only several small pieces had sold despite the strong reception in the press. In fact, that work was completely dependent upon the Acquavella Galleries site for its meaning and never worked very well when it was shown in other spaces, no matter how historic or beautiful.

Following the 1980 show, I had several more solo shows at Acquavella, as well as solo shows at other galleries, lots of group shows, some shows in Europe, limited sales. In 1987, I told myself I was going to stop making art for a while and write fiction. I had become terribly discouraged by the kind of art I was seeing, and the increasingly commodity-oriented nature of the gallery and museum world. I felt that fiction writers were more attuned to, and able to express, the moral and ethical dilemmas of the time – something I felt all artists should be doing. This was my first significant period of doubt about the efficacy of art. But I was also very discouraged by the relative lack of interest in my work. I tried to rationalize this by writing it off to the return of male dominance in the art world, in which so much of the favored art represented women in very sexist ways. What

I didn't yet understand was the importance of money; that is, how much (or whose money) had been invested in your work. It took me a few more years to fully understand that the value and importance of an artist's work is based upon the consensus of a variable group of art world players. Although many curators, critics, other artists, most collectors and even dealers would deny that financial investment has anything to do with aesthetic experience, it is possible to make a case for the opposite by following the progress of an artist's career. I'm not saying that I think money alone determines value, but rather if some career trajectories seem arbitrary in terms of who succeeds and who does not, I believe it often comes down to crucial financial support at a given time. Without the backing of certain key collectors, it can be difficult to get and keep the attention of the various art world powers that determine consensus.

Around this time, I also made a work using an inflatable sex doll. I had never seen one before and was horrified that it reduced the female body to orifices. From there I started looking for ways to explore the relationship between appearance and desire: what does desire and the desire to be desired look like? Since the mid-1970s, I had been committed to an exploration and critique of how gender is represented in the everyday, but after my response to the sex doll, being critical was no longer enough; I needed to create alternatives.

Meanwhile, it turned out to be much harder to write fiction than I had imagined.

In 1990 I was hired to teach full-time at Queens College, and have been there ever since. Early on I realized I couldn't tolerate the insecurity of being freelance, so I traded what then seemed like a lack of freedom for the safety of a paycheck. Although in many ways seeking a secure full-time teaching position was a central goal, having the great fortune to find one in New York City was an unexpected gift. As a friend said to me at the time, "you won the lottery." As is the case with many artists who are hired for teaching jobs, I was chosen through the incredibly generous support and efforts of another faculty member. But at the same time, I had a lot of teaching experience and had given considerable thought to what and how I wanted to teach, which helped me communicate strong positions during the interviews. Also, I had no ambivalence about taking the job. I think all these

factors also made me more credible and attractive to the search committee.

In addition to having more money and more time (new faculty had a reduced course load), my full-time teaching job also gave me access to CUNY funding. These increased resources made it possible for me to collaborate with video and audio artists to produce a series of installations about the *Senses* in 1992. Contributing to this idea was a 1988 conference I had attended at Dia Art Foundation (Dia), "Vision and Visuality (Discussions in Contemporary Culture)," which presented various perspectives on how we see. Vision was presented as equivalent to "eye" sight, and understood as the physical apparatus used for the act of seeing, while visuality was sight as a socially-constructed experience. This distinction resonated with my investigation of desire and desirability. Through designing installations that presented embodied sensory experiences as learned responses rather than as innate perceptions, I hoped to challenge the idea of sexist representations of women as "natural."

Meanwhile two of the *Senses* installations were included in the 1993 Whitney Biennial. I think many artists believe that being in the Biennial assures success. Recently, however, such expectations are so naïve and unrealistic to the point of becoming an art world cliché (as in, "You in Whitney Biennial, why not solo show at MOMA," the well-known Michael Manning meme that both epitomizes and parodies this delusion). Through my teaching job, I had found a fairly comfortable form of economic survival, but I was beginning to question the emotional sustainability of life in the art world. Being included in such a high visibility and high stakes show gave me a chance to see the kinds of behavior that this environment both evokes and tolerates. Going in, I expected I would be treated with respect, but often found the opposite to be the case – once again perhaps a measure of consensus, or lack thereof?

Even so, as the 1990s progressed I garnered a lot of markers of success including a Guggenheim, several New York Foundation for the Arts (NYFA) grants, and one of the last batch of National Endowment for the Arts (NEA) individual artists grants before the Republicans cut off funding. I also had several commissions to make new work for international shows in Europe, solo shows at several New York galleries, as well as at the Institute

of Contemporary Art (ICA) in Philadelphia, at Kunstraums and museums in Germany and Buenos Aires, and talks and a screening at MoMA. Increased recognition, as well as expanded possibilities for doing more ambitious work, accompanied the financial rewards that came with these career bonuses.

Then a serious illness in 1999 caused me to change direction. A year earlier, I had been invited to do a survey show of my work, but as the opening date approached, the museum was in the depths of a crisis among its employees that seemed to make further planning almost impossible. Because I was still recovering, I wasn't sure if I would be able to do the show under those circumstances. Instead of canceling, I decided to try to find a better way to work with the demoralized and uncooperative staff. When I explained my plan – to reserve a large portion of my allotted exhibition space for the use of the museum's staff – I asked each of the employees if there was any way this might help solve their some of their work-related problems.

In response, I created an installation that offered an alternative to a nearly unanimous complaint – a lack of privacy and personal space. In the end I'm not sure how much my project contributed to anyone's well-being; in fact, the installation was never really used by the workers because the director made her disapproval absolutely clear. What I did accomplish was to publicly acknowledge the hard work and contributions of the entire staff (usually such recognition goes only to the artist and curator) while making a point about the collaborative nature of exhibition production. Understanding that all exhibitions depend upon collective input was a new insight for me as well, and despite my sense of failure, I found the process rewarding enough to continue. Since then I have produced "Personnel" (the project's name) for a number of other art institutions.

Sometimes "Personnel", with its focus on institutional problems, created defensiveness among participants in response to what probably felt like personal criticism. In 2008, I had the opportunity to reframe the idea. Together with my colleague Greg Sholette and a group of graduate students, I created the Institute for Wishful Thinking (IWT). Developed in response to an exhibition, "Art As Gift, Periferic Biennial of Contemporary Art" in Iasi, Romania, the IWT's plan was to offer three "wishes"

to each member of the exhibition staff, with the condition that each request be chosen because it would make their work easier, more efficient or more satisfying. Following Periferic's theme, we thought of the wishes as "gifts" that would provide a playful opportunity for staff to satisfy very practical needs, as well as to reframe larger and more systemic problems in a positive light – desires for change. Our approach was to fulfill, in the most literal sense, as many of the wishes as our resources allowed, and where this was impossible, to create symbolic alternatives. Since then, the IWT has undertaken projects with organizations in which we frame the request for wishes in relation to our observations and intuitions about their individual circumstances. In contrast to the response to "Personnel," however, organizations sometimes considered the idea of wishes too whimsical and not serious enough to have any impact on difficult or troubled situations. Through both projects, I've come to understand that organizations and workplaces are delicate social ecosystems, and finding the best way to work with them in a productive, collaborative capacity is never one size fits all.

Even before the 2008 recession, I wanted to find a way to encourage artists and the art establishment to consider how art might address social problems more directly. Both "Personnel" and the IWT had already been working as agents for change when they did projects within workplaces or institutions, working in a manner that has been labeled "embedded" (although the implied references to embedded journalism, armed conflict and dramatic media coverage are way too histrionic to describe the process). Embedded artists (there are a number of precedents, but not enough space to list them all here) perform more like workplace consultants, but rather than use management theory, they bring their own set of tools. Often owing a debt to Fluxus, Performance Art and Conceptual Art, such a toolbox may include some combination of activism, philosophy, urban studies, anthropology and political science, as well as experience in critical thinking and reframing.

In our current project, "Artists in Residence for the US Government (self declared)," IWT has invited artists to propose "embedded" residencies for NGOs, government organizations and agencies at all levels. Based on the successes of work developed

by other embedded artists, as well as through "Personnel" and previous IWT projects, we recognize that the community of artists possesses untapped creative and conceptual resources that can be applied to solving social problems. This call is meant to challenge artists to think about what it means to be active citizens, and how their critical and creative tools might work to create humane alternatives to all those bestial acts that keep the 1% alive at the expense of the rest. •

Melissa Potter
Ammunition for the Virgin
8"x10"
Video still: Stana Cerović, the
last sworn virgin of Montenegro
2012
Courtesy of the artist

I BRUSHED UP against the commercial gallery world in some of the programs and shows I've done, but at a very early stage realized the work I love to do best involves interactivity, community action and dealing with the political topics of interest to me. A huge part of my success has been in coming to this realization early, because I think artists can get very mired in success models that are really not applicable to a particular life – I certainly did for a time. My early years were non-stop art openings in SoHo, and it's good to have a sense of self when entering that world. It is a pervasive value system that is hard to walk away from, especially in the early stages of a career. Being in New York provided me with an incredible roster of choices – like many cities, it is full of alternative art spaces and incredible artist-run initiatives providing opportunities to many different kinds of artists.

I was lucky to roll out of graduate school with minimal debt, which afforded me the ability to live in a wet basement apartment with a dodgy bathroom in Jersey City, and take a not-for-profit job in New York that started me at $15,000 a year. I worked all the time, night and day, to make rent, make art, and eat something other than the horrible, sweet roasted peanuts on the street in SoHo. At night, I did the "Artists in the Marketplace" (AIM) program at the Bronx Museum of the Arts, to which I attribute so much of my success. Having a place to

land after school was crucial, especially when working for a living made so little sense, but was necessary. I often wonder if I would have become like so many brilliant artists I knew who stopped making art because they lost a sense of recognition for what they were doing. AIM gave that to me; it made all the difference in my summation.

It wasn't easy – making so little money was really complicated and meant I had to balance more than one income source at a time, but it definitely provided me with a rich skill set, and the benefit of being around art and artists. While I hungered for making my own art during employment hours, I disciplined myself to make art during non-work hours. I found many brilliant artists who were striking the same balance when I worked as a Program Officer at New York Foundation for the Arts (NYFA), building the NYFA Source database from scratch – the first comprehensive national database of grants for artists. My colleagues held a high bar as Creative Capital grantees, exhibiting artists and published authors. Having these mentors who were living the same life I did was also crucial, perhaps as crucial as my time in the "Artists in the Marketplace" program.

The number one benefit of not-for-profit employment for me was flexibility. I only took jobs that offered at least a month's vacation and leaves of absence. In some cases, these jobs also offered studio access to materials and equipment that were prohibitively expensive, and I spent long hours after workdays producing art. They also gave me access to funding institutions I'd never considered. Eventually, I started writing grants to support my art practice. Dieu Donné offered me five weeks unpaid leave to pursue my ArtsLink award in Belgrade; New York Foundation for the Arts gave me a leave of absence to do a month-long art project funded by the Trust for Mutual Understanding, and later they also held my position open for more than four months when I went to do my Fulbright Scholar award, also in Serbia. These organizations understood that productive artists are the best workers for arts organizations – I know of many other outstanding organizations that subscribe to this thinking (which is sadly at odds with most nine-to-five employment).

I cannot overstate how important these grant opportunities were for me. They allowed me to build a career for myself in Southeast Europe, teaching and making art for more than 11 years now. I believe the Fulbright not only catapulted my career forward artistically, but also gave me the teaching skills I would need in my future employment. I also realized one interesting outcome of these grants was I became one of a handful of Americans knowledgeable about the Southeast European art scene (currently enjoying a lot of play in the museum world), and I started to write exhibition reviews writing for magazines like *BOMB*, *Art Papers* and *Metropolis M*.

In addition, I did a number of adjunct teaching gigs with the hope that one day I'd land a job, though in truth, I was really just unwilling to move. I knew New York was receptive to my conceptual and social issues-based artwork, and it was where I wanted to be. One day, I taught a seminar at Parsons, and spoke at length to a colleague about this very topic. About three weeks later, I got an e-mail from him. He remembered I was a paper-maker, and forwarded a listing for a paper-making teaching position in Chicago! I was inspired he remembered and excited by the prospect, but really skeptical of the location. I'm really glad I went for it. I'll never forget my interview here at Columbia College Chicago: my review committee laughing at all the right moments during my work presentation, really getting and appreciating what it was about. When I got the job offer, I hesitated… for about five minutes.

I have the great privilege of working with graduate students. It is a huge amount of emotional and physical investment, but they inspire my practice, and teaching them keeps me critically engaged with the art world. It's an intensely creative position in which I have an enormous amount of creative control designing my own syllabi, and creating special programming (I created programs as varied as hosting the Guerrilla Girls and a Venezuelan Yanomami community member in my paper-making studio). I've gotten a number of grants from school, and although they are modest, they have come at exactly the right moment to move my work forward, though there are weeks I feel completely subsumed by office hour appointments and committee work, and I admit it makes me frantic. Probably the smartest thing I've learned from my tremendously talented and

productive colleagues is to set time aside for the art with regular discipline. I've had to kill my proverbial "angel in the house:" the e-mails are right where I left them after a day in the studio. It's impossible to do all things right at all times, and so in deciding to be an artist, I finally put my practice above all, even when I get a gentle chastising for neglecting my faculty service duties.

If the AIM program and grants pushed my career forward, my teaching position helped me sustain it. Despite my terror leaving New York (which took me about two years to get over), I make more art and am happier than I've ever been. I've struck a balance between the art-making and the intellectual processes of teaching, writing, and critiquing that deeply inform the work I do. I'm creatively stimulated almost all the time, which is an amazing place to be. ●

BY THE TIME I was in fifth grade, I was afraid to make art in school. Well, to be less specific, I was afraid of school. At the end of the day, if I walked out the front gates, I would be chased by jeering kids who'd yell "gay boy" or clock me in the back of the head with a snowball. Liking art was just another thing that proved to them that I was gay. So I snuck out the back and made my way through the nature preserve behind the building. It was against school rules, was a longer walk home, but it was peaceful and beautiful. I spent huge chunks of time exploring those woods. I suppose this was early training for being a studio artist, spending the majority of my time in my own head, making impractical solutions work.

I drew on my own, secretly dreaming of being an artist. Unfortunately, every time I worked up the nerve to get myself into an art class, I was harassed, culminating in a gay bashing during my freshman year of college. After that experience, I was so anxiety-ridden that I abandoned my plan to major in art and retreated into books. I transferred to a huge, anonymous school and changed my major to history.

Over the next few years, I slowly rebuilt my self-confidence again. At my new school, I took public speaking, joined clubs and volunteered at a junior high school. After graduating, I applied for a graduate program in English – one that would immediately put me in charge of a classroom teaching college freshmen. That was a terrifying flashback, but there was no way I could remain

Michael Waugh
The American Jobs Act, part 1
(detail)
30"x72½"
Ink on Mylar
2011
Courtesy of the artist
Photography by D. James Dee

in my shell while trying to entertain classes filled with 18-year-olds. I also attended every faculty member's lecture and book signing, and got myself elected as student representative to the faculty committee. The best thing was that, six years after being gay-bashed, I started taking art classes again on the side.

When I graduated, the department liked me so much that they offered me a couple of part-time classes. The pay wasn't enough to live on, so I reverted to being 12 and got a paper route, getting up every night at 2 a.m. to drive around throwing newspapers onto suburban lawns. It wasn't ideal, but I earned enough to get by while still having enough time to make paintings in my garage.

With those paintings as my portfolio and glowing recommendations from the English department, I sent out a flurry of applications to MFA programs. All rejected me. I delivered newspapers for another year, improved my portfolio as much as possible, applied to a bigger range of schools. I visited schools in the Northeast and in California, and interviewed with recruiters. Again, all rejected me – sort of. NYU had a small MA visual art program in addition to their MFA. They had rejected me from their MFA program, but they suggested that their MA program might be right. I could attend part-time and work. Given my two-year, 100% rejection rate from MFA programs, I realized that working alone in my garage wasn't getting me very far. I was living amid the cotton fields of Texas, an hour from the closest art gallery. I had no friends who made art. New York sounded pretty good by comparison; the art community was huge – with countless opportunities to volunteer at galleries, museums, or as an artist's assistant.

I moved to New York and got a part-time job. At NYU, I volunteered for as many things as my work schedule allowed. I joined the art student association. I helped organize open house. I went to every lecture. However, working part-time was not enough to pay for living in the city – even with student loans. I considered dropping out, but one graduate assistantship was opening up mid-year. I have no idea how many of the 60-plus MA and MFA students applied for that job. Several of them had already volunteered as much as me, which helped us stand out. But I got the assistantship. The department needed a graduate assistant to help the head of the program – to type letters and do

light administrative work – and (the clincher) to help the other MA students write their artist's statements and papers. With my English degree, I stood out more.

My writing skills kept helping me stand out. When my boyfriend's best friend needed an editor for a short catalog essay, she asked me. I didn't get paid. But this was for Momenta Art, an artist-run, non-profit gallery in Brooklyn. They showed emerging artists who made the kind of conceptual, critical work that I loved.

The gallery immediately asked me to be an intern and donate my writing skills on a regular basis. I helped them edit press releases and grant applications. Soon that internship grew into an actual part-time job. I expanded my role from helping with writing to helping with just about everything else. I learned first-hand how to put shows together, how to hang them, how to ship them, how to market them. What better way is there to engage deeply with both the ideas of art and the practicalities of how art gets shown? Every five weeks, I got to talk seriously to artists about their work, figuring out how to craft their press releases. And then I got to spend weeks living with the work as I sat behind the desk while a range of people came through the gallery talking about the work and asking questions. A lot of students get out of school and never have another serious conversation about art except with their friends (if lucky). That was certainly the case when I was working in my garage in Texas. But working at a gallery kept that discourse alive after NYU.

Everything that I learned through Momenta would have been impossible if I hadn't majored in something that required hardcore researching and writing skills – or if I hadn't spent so much time volunteering in student organizations, learning how to play host to guest artists and to play well with others. If I hadn't forced myself to get used to standing up in front of classes and full lecture halls, I would not have been able to explain a gallery show to a busload of tourists. If I hadn't volunteered and run for office in student organizations, I wouldn't have had the experience necessary to be Momenta's representative on the Williamsburg Gallery Association or an advisory board member of NADA (the New Art Dealers Alliance).

The only problem was that Momenta really didn't pay me enough to live on. I found an affordable apartment, and I found a roommate, so affordable became super affordable – though I still had to put my student loans into forbearance and get other work. I worked for about a year in an architect's office (writing and assembling proposals); I did some art installation at museums; I taught writing; and I was able to get that rarest of all possible teaching jobs in NYC: the last-minute vacancy for teaching an art class, for which I just happened to be in the right place at the right time. At my most busy, I was teaching at two different colleges, helping to run Momenta, volunteering on two boards – while also trying to find the time to make my own work.

None of these jobs paid well; some didn't pay at all. So I had to keep my student loans in forbearance. The interest was capitalizing. But what could I do? I was doing what I'd dreamed of doing from the age of six. But I set a goal for myself: by the time I was 40, I'd need to be self-sufficient, or I'd leave New York. The city was just too expensive to justify letting my debts keep growing. With that goal, I set to work in the only way I knew how: by continuing to remain involved and to watch out for luck.

That luck came through my co-worker at Momenta, the director, Eric Heist. The Brooklyn gallery with which he showed his own work also rented out studios, and when one came open, I took it. I had increased my income enough to either start paying off my student loan or to rent a studio. I chose the studio, my first in New York.

I could finally spread out and develop my work. I had a place to do studio visits. All of the contacts that I had developed were through Momenta, and people who get to know you as a gallerist are not always eager to translate that into knowing you as an artist. I kind of felt like I had when I'd applied to grad schools. I got rejected, put off, ignored. Three galleries looked at my work, including the gallery from whom I rented my studio. Over the next couple of years, I was in a couple of huge, fun group shows organized by friends. There wasn't a lot going on with my art career, but I was grateful.

New York was the first place I'd lived where I was surrounded by like-minded people. Nothing has built my self-confidence

more than that. And these friendships really matter. Lisa Schroeder (from whom I rented my studio) eventually put my work in a huge group show at her gallery, Schroeder Romero. In fact, I proposed the curatorial idea to her and her partner, Sara Jo Romero, and sweetened the deal by offering that the gallery could take over my studio for a month so that the show could be made even bigger. The show would invite everyone who had been affiliated with the gallery space over a ten-year period, including all those who rented studios, like me. I did not curate the show, but they loved the idea, accepted my donation of space, and put my latest drawing front and center. The show came at a perfect historical moment, when artists and gallerists in Williamsburg were taking stock and deciding what would be next. The show was reviewed and my work was mentioned in *The New Yorker*, my first press mention ever. After that success, the gallery offered me a show in their project room. I was a little hesitant to go into business with friends, but we followed the same tentative dance that many artists follow. The gallery didn't give me an actual solo show until after they had sold my work, and after my project room had been mentioned in *The New York Times* and reviewed in *Art in America*. The sales and reviews came before representation.

I suppose being in business with friends can be difficult, but there is also an immense flexibility that it allows. For instance, they gave me a crazy low deal on the rent for my studio. No good business person would have given me that deal. Honestly, without that deal I couldn't have had a studio in Williamsburg. I would have had to commute an hour or more to find an affordable space. Yet, in return, I pay some up-front costs for my shows, like photography and framing. Beyond that, when I've needed help with my rent, they have been there for me, and the opposite has been true, too. None of us could have afforded to stay in New York and do what we do without helping each other.

Of course, the thing for which I feel the most lucky is that the gallery had been able to sell my work. That money, over and above what I earned at Momenta, has been put directly into my career. About five years ago, I could have stopped living with a roommate. Instead, I finally started paying off my student loans and stopped teaching, which gave me more time to work and to undertake bigger, more ambitious projects. Last year, I received

a Pollock-Krasner Foundation grant and a Fellowship from the New York Foundation for the Arts. That money gave me the boost I needed to transition out of having a day job. Instead of working at Momenta, I'm back to being a volunteer. I suppose I could have quit outright. But nothing, not even making my own work, has kept me as connected to the conversation of art.

Perhaps I've jumped the gun by quitting my day job. The grants and sales aren't quite enough to pay all my bills. The tough choice I've made has been to sublet my studio. I could have kept the studio and kept my job to pay for it. But my own work is so incredibly labor-intensive that time is more precious than space. At least for the next few years, I am committed to finding alternative ways to produce my work, to borrow space, work at home, attend residencies. Often this is inconvenient and I sometimes feel like I've slid backwards. But I'm now working full-time as an artist. It's a pretty good alternative.

When I was in fifth grade and snuck out the back of the school, that was a pretty good alternative, too. The woods covered 320 acres. They were gorgeous, deep, a huge unknown. No other kid followed me into the woods. I learned every path. I drew a map within my head. Teachers made them out to be a terrifying place full of child molesters and wolves. But imaginary fears were nothing. The alternative was to walk bravely out the front door to face my very real tormentors. I would have only learned the depth of their harshness. Being an artist is not a normal career. You don't walk out the front door into it. ●

THE QUESTION, "how do I do all those things?" always makes me uneasy. Yet it is a perennial and predictable inquiry, and one that I never can never fully decipher. This is because at its core the question is both ideological and emotional. Simply put, I did not escape the middle-class, middle America imprinting of growing up in a small manufacturing river town in Wisconsin. So anything short of an analysis of Max Weber's Protestant work ethic, the sociopolitical underpinnings in eastern Wisconsin during the Cold War, and an ever thorny and interwoven psychological profile would fail at getting to the heart of my deep-seated and profound drive to work.

So my shorthand answer to "how do I do all those things?" is always credited to my husband, Brad Killam, who is also an artist and art professor. As teachers, we are both designated atypical work structures that for the most part also correspond to our kid's school schedule. This flexibility provides for bursts of creative output throughout the year. The downside is that daily work has to be negotiated, and the result is inconsistency. We are in a regular state of building a graceless schedule that is driven by projects, exhibitions and writing deadlines. The fact that we have different art world careers and art world trajectories is cause for ongoing dialog on differing art world positions: worth and merit, public and private, regional and global. These dialectics, and the practical exchanges we are

Michelle Grabner
Untitled
36"x36"
Silverpoint and black gesso on panel
2012
Courtesy of the artist and
Shane Campbell Gallery

forced to embrace, also establish priorities and realities to build our schedule around.

With our teaching posts, studio practice and host of art-related projects endlessly orbiting through our lives, we have learned to fold parenting and pedagogy into the rotation of obligations and opportunities. With three kids – two of whom are now welcomingly in college – most everything we do, either out of plan, necessity or misadventure, becomes a teaching moment. There is no doubt that we perpetuate the unconventional "art parent" cliché as we drag our kids out of school for projects in New Haven or Cologne. Or as we expose them to other artists, who like pilgrims, stay with us in our yellow stucco house in Oak Park as they make projects at the artist space we have run for 12 years. Unequivocally, we have and continue to offer our kids an alternative way of thinking and being in the world. Yet sacrificing some of that customary parenting script can also be difficult, and at the very least challenging, for kids at different developmental stages. For example, our 7-year-old daughter is only now starting to identify that her family behaves atypically. But for the moment she is still game. We know from our experience with our two older sons, her curious compliance will not last for long.

Finding great pleasure and satisfaction in pragmatically negotiating my given resources and profound limitations is an obvious underpinning to my production habits. But I am careful not to confuse my continuous impulse to learn and deliberate with that of personal ambition. It takes too much work to arbitrate the meaningful work of making art. To braid it into all aspects of life is the only way to make it worthwhile.

And while the previous commentary opts to address the unasked "why" in the question "how do I do all those things?" the following is an attempt at sketching out the "how" in some of the work I do.

THE STUDIO

My studio work bends and folds into and around everything else – with the exception of an early 4:30 a.m. routine that gives my studio practice its own resolute rhythm. This three-hour window before I head into the house to make breakfast and

help get the kids to school is the only uniform time I dedicate to the studio. Then, depending on the day, I may head back to the studio and work until the evening. If I am teaching or if I am in the office that day, I may not return to the studio until the next morning. Or I may head back out in the evening after dinner and homework. Outside of those day-breaking hours, the rest of the time in the studio is a daily deliberation with other activities. It is also important to note that my studio is above The Suburban galleries, just steps from the back door of the house, so hideous sweatpants and flip-flops with wool socks provide no obstacle to work. In the summer when I am in Wisconsin, my studio time is brokered with the Poor Farm, mowing, and gardening. And for those times when I am traveling, I have devised a series of work adaptable to planes and hotels.

THE SUBURBAN AND THE POOR FARM

The Suburban is an artist project space that I run with my husband, Brad. Since January 1999, we have hosted over 150 artists in two small galleries that are located on our property in the West Chicago suburb of Oak Park. We host shows every six to eight weeks. I head up the administration aspects of The Suburban, which means I am in contact with artists at different stages of their project: from scheduling dates to lining up visiting artist gigs, picking artists up at the airport to sending them gallery floor plans. Brad, on the other hand, shores up the physical ends of the program. Where I send out the e-mail blasts and update the website, he builds crates and arranges for the return shipping of work, builds pedestals, wires new light fixtures and puts beer on ice for the openings. In other words, I carry The Suburban's long vision and historic arc while Brad steps in and takes care of immediate exhibition needs. Once artists are here and on-site (most often staying with us in our home), we take turns negotiating the artists' needs and expectations with that of the family. This includes making pancakes for the artists and our daughter, to running to the village hardware store.

Where the Suburban is comprised of two very small galleries and located in an urban setting, the Poor Farm (built in 1876) is a sprawling exhibition space with a dormitory building located in the farm fields of northeastern Wisconsin. Unlike The Suburban, The Poor Farm is a not-for-profit project, but my

tasks are similar to The Suburban. The Poor Farm hosts year-long exhibitions and comes to life in summers, when we concentrate our time there with a rotation of other artists-in-residence. Embarking on our fourth year of programming, we manage the Poor Farm with administrated attention spread lightly over the course of the academic year, and then ramp up the physical care and direction over the summers. Between November and March, the Poor Farm sits in a state of hibernation. Because the Poor Farm is evolving slowly as an institution, and changes with the seasons of the upper Midwest, this ambitious project can work because, for now, we have its impact nestled into in the high production of summer, and not actively competing with our other work and obligations.

BUSINESS REALITIES

And like the integration of art and the domestic sphere, the commercial realities of the art world are also shaped by a regimen of cyclical compromises. As it is with most aspects of my social negotiation – business, parenting, curating and teaching – three factors come into play. A combination of style, belief, and pragmatics – with a heavy emphasis on the last two perspectives – govern my relationships with my commercial dealers (and most art world dealings for that matter). Because the value in my studio art practice is located in the process of conceptualizing and making, I can play it "loose" with my dealers, and with critics and curators with whom I occasionally interact. And because their mandates are grounded in a very different value system, I can only trust that they work in my best interest; and sometimes they do and sometimes they don't. But as long as I have the privilege and discipline of studio practice, coupled with the opportunity to explore exhibition context and display schemes in my work, I fully entrust dealers with the business aspect of distribution and consumption, curators with zeitgeist, and critics with judgment. Strategically, this is not an ideal position for artists who are driven by the drama and celebrity of art world success. I am perfectly aware that dealers and collectors engage in repugnant, self-realizing relationships that result in heaps of fictional value-building. Opting for an unconfined relationship with the business of art may provide

for a greater scope of artistic freedom, but it can also mean less visibility on the "scene" driven by cultural capital.

TEACHING

I am gratefully indebted to The School of the Art Institute of Chicago, an art institution that has been able to vividly discern and support the connection between outstanding teaching and engaged practices. I work in an institution that expects me to be in the studio and professionally active when I am not in the classroom. This should seem an obvious value in higher education, but those who teach know that it is becoming a rare attribute. Teaching gives predictable structure to my week, requiring me to be in the classroom on certain days. Now that I am chair of the Painting and Drawing Department, my time in the office and attending meetings is less predictable, changing as the arc of the semester changes. Flexibility is the pay-off for the relentless and attentive schedule-building required of department administration. And after two years in this position, I realized that I am not effective at slipping between teaching and management. The language, vocabulary and analytical reasoning required of administration is drastically different, even opposed to teaching. It is also true that my brain is not facile enough to move between the two types of discourse. Regardless, I have learned not to intertwine teaching and administration, but instead relegate separate days for each activity.

WRITING

Writing is dreadful. As much as I enjoy deliberating on theories of art and practice, the act of writing is difficult. Profound dyslexia is to blame. Writing and reading is painfully slow, so I indulge myself and write in bed under a big down quilt, with books stacked in piles next to me. I earmark whole unadulterated days to writing. However, the dread of the process is always mitigated by what is learned, and the synthesis of pulling together research. And to be most transparent, procrastination should not be underestimated, as I can accomplish impressive amounts of guilt-induced housecleaning and studio work when dodging deadlines. I have learned to harness this energy. And it is my guess that most editors know they are entangled in these psychological head games with writers, and I am always indebted to their expertise. ●

IF I'VE HAD any credo in my creative life, it has been: keep it cheap and put everything back into your practice.

Every job that I've had has been tailored to meet my creative needs at the time. When I was still an undergrad at Pratt, I took a job at the Met in the color print shop during the King Tut show because I wanted to meet other artists. I needed the money, but I really wanted to be a part of New York's culture in a broader way. There were theater people, musicians, film-makers, as well as painters and sculptors. No one was going to be there for long, but it was a great place to meet other creative people. It turned out to be a good move on my part as one of my co-workers introduced me to Aeropress, which was an intaglio studio for artists like Claes Oldenburg, Tom Wesselmann, Susan Rothenberg and Brice Marden. I ended up being Brice Marden's Master Printer for three projects, and getting insights into the studio practices of some of the most important artists in the world. I was working four days a week at Aeropress, and doing my work at night and over the weekends. I remember going home on the R train exhausted, and trying to stay awake and excited about my own work. The hardest part of that job was knowing that you were putting a lot of your own creative energy into someone else's work. I found that I couldn't do it for long, and left after a year-and-a-half.

A friend from college asked me to do some comp drawings for an advertising agency that she worked at. It turned out that

Peter Drake
Day for Night
65"x65"
Acrylic on canvas
2006
Courtesy of the artist and
Linda Warren Projects

I could work freelance for one week and get enough money to survive on the Lower East side for a month. This was 1980, so an apartment on Delancey and Attorney was cheap and I was getting $50 an hour – crazy money for that time. Having this kind of uninterrupted time allowed me to develop as an artist faster than I could have imagined. I had the time to start getting my work into shows at non-profits and galleries in the East Village. This was a great time to be a young artist because so many young people were just opening their own galleries, even if they were just in their studios.

I started showing with a gallery. The dealer was great to work with. She was young, energetic and totally in love with all of her artists. She did a lot of career development and reached out to other galleries to get her artists into group shows. She was also a blast to hang out with. I found that for the first time I could survive on the sales of my own work, and stopped taking freelance work. It was a little nerve-racking, especially when someone would call with a good job. I managed this for a while, but when the Drawing Center called to offer me a job as an artist/advisor, I decided to take it. I had to look at other artists' work one day a week, and then make recommendations for group shows. It was actually a great place to work, and the staff there was really sympathetic to artists. It gave me enough money to pay for a studio in Bedford-Stuyvesant where I started working ten or twelve hours a day. Fantastic!

Later in my life, a good friend who was working at Parsons asked if I would be interested in teaching there. I never had any intention of teaching when I was studying art, but I decided to give it a try. One way or the other, I have taught one day a week for the past 20 years. This was exasperating at first. I am extremely self-conscious and anxious most of the time. Teaching is bit like being onstage, and some people naturally gravitate towards it. It gave me nightmares. I literally couldn't sleep the night before teaching no matter how hard I prepared. Eventually, I just accepted this as a condition of teaching and have learned to live with it. I learned to enjoy the moment when you see a student's vision emerge. Teaching also created some of my most lasting friendships. Teaching requires you to be completely honest about your strengths and weaknesses as an artist. It's hard to be lazy in the studio when your students are blossoming all over

the place. I have lectured, taught or mentored at a number of different schools, including Parsons, Maryland Institute College of Art (MICA), School of Visual Arts (SVA) and the New York Academy of Art.

Recently I was named the Dean of Academic Affairs at the New York Academy of Art – a graduate program in Manhattan. I went from working five or six days a week in the studio to working five or six days a week at school. This has taken some adjusting. To a degree, it has meant that a lot of my creative energy goes into the Academy. Because I believe in the school and have a profound belief in its future, this feels like an important thing to do. I have just recently begun to find a way to do my own work at home in the evening and on the weekends. This makes for very long days. You have to have an understanding partner to do this.

Probably the most important decisions that I've made in my life have been who I fell in love with and where I live. My wife, Janice, was raised on a dairy farm in Wisconsin. I know that she viewed her parents as partners and equals in running the family farm. She has always viewed my life as an artist in the same way. We are both collaborating on my creative life as partners. Her ability and willingness to manage my relationships with the dealers that I work with, and to facilitate my teaching career, have allowed me to focus most of my time on my art. She is also the most supportive person in my life. I don't understand artists that have destructive partners. I believe that it is incredibly important to have a supportive environment in order to grow creatively. Janice keeps the balance in my personal, academic and art life. She is responsible for the daily running of our lives and my studio. For my studio, she communicates with galleries, creates consignment forms, arranges deliveries, applies for grants, keeps my archive up to date, and creates a Web and social media presence for me. This can be a full-time job, and that means that we survive on one shared income, but I think that it is a model that other artists could use if they are willing to take the risks and endure the anxiety of a single income.

We were also lucky enough to get an apartment in a Mitchell-Llama building in 1990. We were on a waiting list for about a year before we moved in. Fortunately, we were on a year-long artist residency in Germany at the time, and the apartment came up when we got home. These buildings were designed to keep

middle-class families in New York. Your rent went up or down depending on your finances. For an artist, having an apartment that wasn't going to drag you under if you had a bad year was incredible. I could not have lived and worked in New York City without this apartment. There are virtually none of these buildings left in NYC.

I have had great relationships and a couple of horrible relationships with the dealers in my life. In most cases, I try to be a team player and advance the cause of the gallery in any way that I can. Sometimes I have curated shows that bring more attention to the gallery or introduced artists, writers or collectors to the dealer. The relationship of the artist to the dealer has obviously changed over time. The idea of a primary dealer who is in control of your entire professional life is almost extinct. Most galleries do not have the staff to engage in real career development, and so that has fallen more to the artist to accomplish than the dealer. I do believe that the healthiest professional relationships that I have had over the years were and still are collaborative. I expect and get honest criticism from the dealers that I work with, but not any form of direction. This is pretty hard to pull off as you could argue that honest criticism is direction, but the best dealers instinctively know where to draw the line. I'm fairly low maintenance as far as contact is concerned. I can go for months without speaking directly with some of the dealers that I work with, and others I'll try to speak with once a week. The dealers that I have enjoyed the most in my life have been enthusiastic, visual sensualists. Their joy about art and artists is visceral. One of my favorite dealers is someone who just calls me when I'm in the studio and we'll talk for an hour about nothing. It's just a chance to connect to someone who is sharing your life. The one deal-breaker for me is non-payment without negotiation. I know that everyone gets behind from time to time, and as long as a payment schedule is negotiated I'm pretty willing to be flexible. One of my favorite dealers pays the artist before anyone else just to make sure that she's not tempted to think of the artist's share as a loan. In the long run, the best professional relationships that I have had have been open and honest. The art world is an extremely anxious and subjective world; the last thing that you need is to be second-guessing your work or your relationship to your dealer.

WHEN SHARON CALLED to talk about this book, it immediately made me think of a strange experience I had about four years ago. I was in Los Angeles, a few weeks into a six-month project – a commission to make an installation for the new headquarters of a law firm in Boston. My proposal involved taking photographs in each of the 14 cities where they had an office. I'd been making work like this for a while, but this was an opportunity to work on a scale beyond what had been possible before. My client was enthusiastic and supportive; my whole travel itinerary arranged for me, and if things got complicated, help was a phone call away. I'd just arrived in LA from Hong Kong, having begun in Tokyo a couple of weeks earlier, with nine US cities to go before returning to London, where I live. I was making work I wanted to make, in places I wanted to go to, and was creating something of value for my clients. Walking around downtown with my camera in the sunshine, I think I was feeling really good about being an artist that day. And then I saw a faded yellow sheet of paper pasted to a lamppost, which read:

ARE YOU AN ARTIST?
DO YOU NEED HELP??
WORKSHOPS AVAILABLE

It then listed a long series of issues an artist might have:

Peter Newman
Los Angeles, Downtown
39" diameter
Diasec-mounted C-Type
photograph
2008
Courtesy of the artist

Perfectionism
Creative block
Overproduction
Difficulty talking about your work
Unrealistic expectations
Overcritical of your work or of others
Money problems
Mood swings

…and so on.

I may have some of the detail wrong, but you get the picture. I was so taken aback, I couldn't actually take one, although I wish I had. Damn! Was it really that difficult? Is it some kind of condition? Is it contagious? The sign read like recruitment for *Artists Anonymous: 12 steps to creative satisfaction*. I actually felt kind of angry and a little defensive that artists were being represented this way. But I guess what threw me the most was that I'd be lying if I said I hadn't felt all these things myself at some point. The fact that perfectionism topped the list made me laugh out loud. I'd just been taking hundreds of photographs of the very same thing.

I got back to work, but thought about that piece of paper for a long time. It was a reality check when I was high on good fortune, and I was grateful for it. But what was it doing posted there anyway, in the business heart of LA? In fact, somehow the whole thing seemed a little uncanny as it was just so perfectly pitched. So considered, with all points on a spectrum covered. Yet honest and thought-provoking, I began wondering if it was an artwork itself, and maybe a joke was slowly dawning on me. Here I was in the center of a city, surrounded by impressive buildings that conferred status on the artwork in their foyers, and I myself happily involved in such a project. Yet out on the street, with this thin piece of paper, an aspirational idea of a freewheeling and successful artist had been brilliantly complicated. Intrigued as I was, sadly I didn't have time to find out what was on offer at the workshop. I'm not quite sure if the artist deal is really quite as tough as the sign made it sound, but complex it certainly can be.

I've been working independently for some years now. By independent, I mean I don't have a main gallery representing me and through which I'm usually reached. I often work directly with clients and institutions. I do work with an agency that specializes in public commissions, but I have to make a lot of connections myself and also make sales, neither of which come particularly naturally for me. I remember finding private views very intense and quite a lot of work. Now I'm much more at ease with the necessity of putting yourself forward, even if you are with a gallery. I don't find the process of selling the work to be so different to selling an idea, but I do find pricing difficult. I think it's just really hard for an artist to put a value on their own work. I've got too much invested in it already, so it's useful to get an opinion from someone else. Left to my own devices, I tend to either overvalue my work or practically give it away, depending on my mood and some other fairly random factors.

Perhaps part of my independent approach came from being at Goldsmiths College in London at the time of the now infamous "Freeze" exhibition. To see the older students put on an exhibition of their work outside of college was very influential. The idea of taking the initiative with regard to your own success has been a given for me since then. In fact, it was a model I followed a few years later by putting on a show in an empty building myself. I didn't sell a thing, having put all the money I had into it, but it was reviewed by *Time Out* magazine. This led to other things, including a few years with a gallery, and effectively started my career.

Something that definitely helps me sustain myself independently are the relationships I have with art consultants. This has been essential, and I'm truly grateful for their support. Many are also working freelance, and even the large consultancies seem more than happy to work directly with an artist. I think the dialog between artist and client can be more immediate and engaging that way. I've certainly enjoyed this, and the dialog seems to be an important part of any commission. Not that it will change the nature of the work, but the exchange is often about more than simply the installation at the end. I find it very rewarding to learn about the world of a client and their motivation and hope that's reciprocated.

One of the most important experiences I had when I first started showing my work was with a private collector in London. He invited me to meet him at his offices, and after talking for a while he asked:

"So what's the work you've always wanted to make, but haven't been able to?"

Good question! As good as it gets. I told him I wanted to make a video of someone trying to do yoga in freefall. Right there, he committed to buy it, so I was able to go out and make the work. It was a leap in every sense for everyone involved. I asked if I could make it as an edition of three, with the first one going to him. That way I could spend everything on the production and hope to make something back later on. We had a deal. What really impressed me was not just his ability to have confidence in an idea, but also how much he clearly enjoyed being involved in a creative process. One of the editions ended up being bought by a museum in Japan, and was projected onto the outside when it opened in 2005, seven years after the work was made. The piece has also been shown in other locations and countries. I realized never to underestimate the possibilities of a commission or the support of a good collector.

As glad as I am that I've been able to make it work as an independent artist, I am now involved in talking about representation for the future. Maybe I hit a glass ceiling or perhaps it's just getting older, but I now feel that to take things to the next level will require working with the right gallery. I think I've enjoyed feeling like an outsider, but when I've been represented in the past, I've usually felt more secure. I'm also aware I've lost out on some projects as I couldn't offer the reassurance of a gallery. Ironically, or perhaps because of the unlimited possibilities of the medium, the art world can be surprisingly conventional when it comes to career development. One of the hardest things I found is finding the right balance between the social aspect of the art world, through which you meet the people who can make things happen, and the practical side of just getting on with making your work. I've certainly over-involved myself in each of those aspects at times, but more so when independent. I think you always have to be involved in your own promotion, but my priority now is to free up time to focus on making the work, and to be able to think a little more about the bigger picture. •

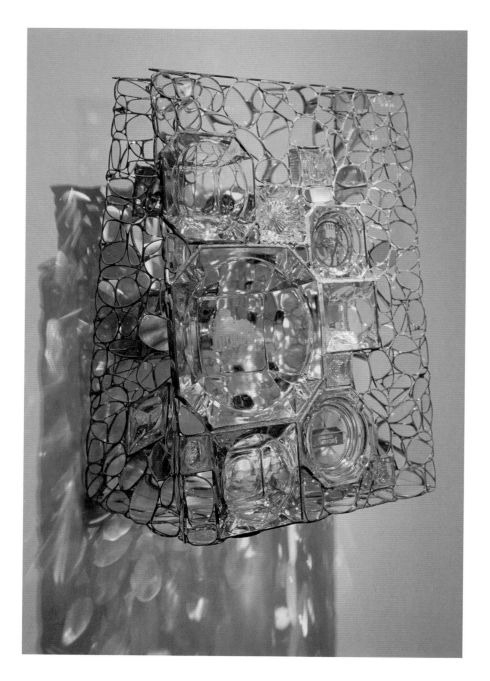

I WAS RAISED in an art world where people believed that anything that distracted from a studio practice[1] was somehow negative. Even teaching – as respected and stimulating as it can be – was looked at primarily as a way to pay the rent. This model, at its core, believes that art-making is humankind's highest calling (or at least its coolest activity); a position that wears thin with the objectivity that comes from even modest maturity and self-awareness. I believe that living a full and creative life means embracing cultural activity in the broadest possible way, while maintaining a healthy skepticism about much of it. I've sustained myself (both spiritually and financially) for close to 30 years by doing more – not less – culturally, and by pursuing opportunities and interests in wildly different directions. Guiding me has been one of the philosophical beliefs at the core of Modernism, going back at least as far as Wagner's *Gesamtkunstwerk*: a full integration of all cultural activities, not their compartmentalization. This thread that advocates for integration goes back to the Arts and Crafts movement, through the Bauhaus to Joseph Beuys, and onward to today's "Relational Aesthetics." Many believe in this narrative, yet on a practical level we generally still look at the art world as a pyramid with the solitary artist at the top, working diligently in his or her studio.

I've worked in the museum world for over 20 years now, and I'm frequently asked "how I do it?" That is, how do I

Richard Klein
Bag
20½"x15"x9"
Ashtrays, eyeglasses, found glass objects, mirrors, brass
2011
Courtesy of the artist and
Stephan Stoyanov Gallery

consistently work in the production end of the equation while simultaneously working in the presentation side? First of all, I am fairly disciplined; I work in the studio almost every day, even if just for 20 minutes. In fact, I would say that my studio practice is the only true discipline I have: a consistent regimen of focused mental and physical activity. The other, more important, component of "how I do it" is the need I have for variety and stimulation. Art, as we all know, is about ideas, not about objects, and I am a self-admitted junkie for novelty – I thrive in the presence of new ideas – and the solitary world of the studio doesn't consistently provide the inspiration I require for a full and active intellectual life. In my role as a curator, I am often drawn to things I am curious about but don't completely understand, and this process of engaging directly with the ideas and passions of others fuels my process in the studio. A wonderful day is one where there is direct correlation between something I've been thinking about in the studio and something I'm working on in the museum environment. Now, every day is of course not wonderful; for every good day there is a day of disappointment and disillusionment, both in the studio and in the museum. This reminds me of "Gotta Serve Somebody," a song by Bob Dylan from his gospel period: "You might be somebody's landlord, you might even own banks, but you're gonna have to serve somebody." Indeed, in the museum I need to serve institutional interests, but in the studio there is a bigger and meaner taskmaster: art history. As much as I live in the two parallel worlds of production and presentation, I have to truthfully say that for me making good art is the infinitely more difficult proposition.

Along with the making of art, there is the associated (and necessary) activity of getting it out into the world. This is something I've never been naturally good at, as it requires a basic art-as-business mindset. For my own sanity, this is one area where I try my best to keep my studio practice away from my life as a curator, as it is an area fraught with conflict of interest issues. In fact, as far as the public is concerned, there seem to be two Richard Kleins: the artist and the curator. I am generally scrupulous about not having the mercantile side of making art get intertwined with my role as a museum professional (this is one area where total cultural integration is not such a good idea),

and in the instances where these opposites have overlapped, I always try to err on the side of institutional interests. This is not to say that working in the museum world doesn't provide opportunities outside of it, but it is from the position of being perceived co-equally as artist and curator that many of my most significant ancillary experiences have been spawned.

In my dealings with the gallery world, I bring a fair amount of experience and knowledge from the museum side of my practice – a situation that certainly helps with practical considerations. These considerations include everything from installation logistics to knowing how to draft a press release that serves both intellectual and business interests. One thing I have learned is to generally defer to the opinion of a gallerist on financial matters (such as when to offer a discount), based on an understanding that the gallery is primarily a business that exists to make money, whereas for the artist, making money is the happy collateral from making art. In my experience, I have found that it has been better for me not to expect my gallerist to be my soulmate in the studio: it's nice when they share similar intellectual and aesthetic interests (and they should understand enough about what you are doing to talk to the public about it in a way that you don't find embarrassing), but their primary jobs are: (a) exposure; (b) sales; (c) generating reviews/criticism; and (d) getting the work into other exhibition venues.

One component of my studio practice that is critical for the balance between art and the rest of my life is the fact that I have my studio as part of my home. I've maintained separate (and distant) studio space in the past, and I find it is inefficient with both time and money, and the combination of living and working in one location is incredibly helpful on many levels. For instance, at least several times a month, I will wake up early in the morning – 4:00 or 5:00 a.m. – and find myself obsessing about whatever I'm working on in the studio. With the studio door about 18 steps from the bedroom (yes, I've counted them), I'm able to get up and immediately go to work. The amount I've accomplished over the years in these pre-dawn hours has been significant, and it has the added benefit of giving me a psychological boost before the usual daily wave of multitasking really hits. (I also do the majority of my writing at home.) An additional built-in advantage of working at home is having

access to 24/7 art assistance and criticism: my wife, the painter Mary Kenealy. (Mary, if you are reading this, thanks for helping me get that crate out of the basement last week, and for patiently holding that section of the sculpture while I soldered it.)

So, the question is ultimately about living a full life, where all of one's interests and abilities are equally served. I'm reminded of the comment of a high school guidance counselor, one of the few instances where as a young person starting an arts career I was given truthful advice: "You know, a life in the arts is difficult." This was given to me as a warning, not as the promise of something infinitely interesting. The various things I do, both in and out of the studio, are all critical components of a *Gesamtkunstwerk*. I can't imagine living life differently. •

[1] The following is a short, abridged listing of all of the things that I have done in the art world, from the age of 20 onward, in no particular order: made art (studio practice work as well as public art); taught art-making, including drawing, bronze casting, and three-dimensional design (middle and high school, college, senior citizens, prison inmates, etc.); worked in a gallery selling art; worked as an art conservator/restorer; written about art (from criticism to scholarly essays); acted as a professional consultant to arts organizations and institutions; served on the boards of various visual arts non-profits, including alternative spaces and museums; founded (along with others) a visual arts non-profit organization; lectured on various topics concerning contemporary art (from university settings to adult continuing education); worked as a visiting critic for both university Studio Art programs and Visual Arts residency programs; acted in the role of guest curator for both visual arts non-profits and museums; worked in the museum world, both in curatorial and administrative roles; provided consultant services for art collectors (purchasing, conservation, collection management, lighting, etc.); acted as a nominator or artist reference for various visual arts granting agencies; acted as a juror/consultant for public art programs; and advocated for and consulted on artist housing projects.

WHILE AT PRATT, I received a grant from the Dana Foundation to do an internship at a fine art picture framer. Dana grants were specifically designed to encourage artists to find employment, recognizing that we were about to join the population of the perpetually broke. Being a picture framer is among the ranks of the post-art school, low-wage worker force – artists that make the art world run. Art shippers, installation crews, gallery clerks, photographers and assistants are the kind of jobs where you call in sick and everyone knows your lying because you're really trying to finish a painting for that upcoming studio visit.

The frame shop was one of the best in the country, and I ended up working with great artists like Jasper Johns, Robert Rauschenberg and Claes Oldenburg, as well as numerous important art dealers. I was able to make connections and build lasting relationships that, to this day, are part of my life as an artist. In a few years, I was starting to show my work, and eventually I was making more money selling my work than my frame shop salary. I quit my job and remember lying in bed at night, staring at the ceiling thinking, "What have I just done?" I soon learned that being a "represented gallery artist" is a roller coaster ride of financial ups and downs.

Maintaining an apartment in New York City is more than most people can comfortably handle, never mind the added responsibility of an art studio. Rent, supplies, fabrication, utilities and assistants are the making of a small business, and

Sean Mellyn
Fat Cat (detail)
15"x12"x6"
Oil and glitter on canvas, resin, wood, modeling paste, paper
2011
Courtesy of the artist

I learned very quickly the discipline it takes to sustain the operation. I also learned that selling paintings was not going to pay for it all, if ever.

I breezed through a series of part-time jobs, from returning to framing, to being a personal assistant to an art collector. I also have taught, but that too is a roller coaster ride; an adjunct professor may or may not teach according to enrollment. There was very little I could do that did not hurt my sense of who I was: an artist who regularly shows and sells his work, and an artist who is heavily involved in his studio practice.

Through an interior designer friend, I started to do interior styling. Interior styling is work that has evolved for me over the years, and takes very little time away from my studio practice. There are also some funny job titles for this kind of work, like "Accent Specialist." I primarily work on photo shoots, composing and arranging furniture and objects for the best picture or "story." My styling work has been published in magazines and books, and I have expanded to retail environments and staging apartments for sale. Styling is, in a sense, an extension of my studio practice, using intuitive skills I would employ creating an installation or building sculpture. It took me a while to understand how to arrange a three-dimensional space and its objects for the camera, which flattens and foreshortens everything. I use my knowledge as an artist to inform an arrangement or problem-solve a difficult tableau. I think about the historical relationships artists have with interior spaces from Van Gogh's bedroom (that chair is *exactly* in the right spot) to Mattisse's brilliantly hued studio. I think about artists whose practice involve the construction of a way of living; Andrea Zittel, Franz West or Rirkrit Tiravanija. I like solving the pictorial problem as well. Picking apart peony petals and strewing them Chardonesque across an otherwise dreary sideboard, or crowding glass bottles like soldiers in a Morandi still life.

My work has always had some element of domestic life. I've made paintings of refrigerators, light bulbs and trash cans. I've made pillows, painted couches and made lamps. Rauschenberg's *Bed* made an early and lasting impression on me – that art can not only be made from anything, but material extrapolated from a life lived is a powerful statement. •

HOW HAVE I sustained a creative life for the last 20 years? I followed my instincts.

In the early days, life was simple: my priority was painting. I supported myself doing paste-up at *Vogue*, *Condé Nast Traveler*, *National Lampoon*, and other magazines. When the freelance work dried up during the 1989 economic downturn, I lived on a Pollock-Krasner grant for a year, then enrolled in the MFA program at the University of Connecticut (UConn), with a tuition waiver, a stipend and a teaching assistantship. In short, I adjusted my life to suit my economic circumstances.

On account of my design background, a New Jersey community college offered me a job teaching computer graphics shortly after I graduated from UConn. I would have preferred to teach painting, but, being pragmatic, took the job, which gave me the wherewithal to pay for studio space in Brooklyn and enough free time to paint. Over the next few years, I had several solo exhibitions at galleries in New York, Providence and Philadelphia, and sold a fair number of paintings. But good times, I have learned, come and go.

After 9/11, my galleries closed. In some ways, it was just as well. I'd had a baby and taken a demanding tenure-track job teaching graphic design at a public liberal arts university in Connecticut. I had little choice but to shelve painting anyhow. I had lost my studio in a divorce, and I had begun working on some more experimental projects that involved digital imagery,

Sharon L. Butler
Poorly Masked Shape
23"x18"
Pigment and urethane on linen tarp
2012
Courtesy of the artist

animation and installation. I completely ignored painting for several years until I had the freedom that tenure allowed. When I moved into a new house and needed some artwork for the walls, I made knockoffs of Ellsworth Kelly's *Falcon* and Georges Braque's *Le Jour*. It brought back how much I loved the painting process – the smell of the turpentine, the bounce of the brush on the canvas, and the meditative process of making *objects* – and I fell in love with painting again.

I was out of touch with contemporary painting, so each day I scoured the Internet for criticism and reviews. Disappointed that there were so few online sources devoted specifically to painting, I created *Two Coats of Paint*. Back then, blogging was still outside mainstream media – few academics or journalists respected blogs or bloggers – but *Two Coats of Paint* optimally combined my interests in digital media, art criticism and painting. I was completely absorbed. Although other artists and colleagues may have thought that blogging was a distraction and a waste of time (not peer-reviewed!), *Two Coats* became an integral part of my art practice, and gave me a voice in the larger art community. I began publishing articles for other publications like *The Brooklyn Rail* and *The American Prospect* to draw attention to the blog, and writing, too, became an important activity for sorting and articulating my thoughts about my work and others'. When *Two Coats of Paint* eventually gained respectability in the academic community – sponsorships from organizations like The Whitney Museum, the Brooklyn Museum and MoMA helped – I felt empowered, as though I was contributing something worthwhile to the community. As a result of writing and blogging, my painting has grown, and I've been invited to participate in many collaborative projects and exhibitions.

Of course, working in academia for many years gave me the financial freedom to ignore the art market and pursue independent, uncompensated projects like *Two Coats of Paint*. But teaching graphic design became increasingly burdensome, as my interests veered toward painting, Web 2.0 and social networking media. Contemporary art is intensely cross-disciplinary; the art department where I have been teaching for 11 years is not. I worked gingerly to incorporate the

subjects that interested me into a broader digital art and design curriculum, but, like many artists, I'm not politically adept at office politics, so building alliances with other faculty members is an ongoing challenge. Nonetheless, I like engaging students in my projects, teaching them how to create artists' books using on-demand publishing, how to build community, how to make art using Web 2.0 tools and how to publicize their projects. After being promoted to the rank of full professor, I took a leave of absence to prepare for some exhibitions and spend more time on my own projects. Ultimately, I returned to my position, and, although I faced strong opposition from my colleagues, I requested reassignment to the Painting and Drawing Program.

From my early monk-like devotion to painting alone, to a cross-disciplinary embrace of digital projects, writing and abstract painting, my art practice has changed tremendously and unpredictably over the last 20 years. Recently I've concluded that I'm better off following my instincts, no matter how non-linear or disjointed they seem. For me, the process is always going to be (a little) more important than the tangible product or conventional success. Had I maintained my early vision of a hermetic painting life, churning out series of nearly identical paintings year after year, I would never have discovered my love of writing or had a child, both of which have made my life enormously rich, if also heartbreakingly complex. At 53, it seems easier to plan and navigate the years ahead, but perhaps the future will bring equally unexpected opportunities and challenges. You never know. •

THE ANSWER TO how it is that we do what we do has inherent paradoxes and paraconsistencies. On one hand, we are absolutely confident and clear about our interests and direction, as well as how to accomplish whatever goals we may have. Concurrently, it is all a mystery as to the fact that we live as we do, and that we are able to conduct our lives as we do.

We survive (make a living, pay bills, taxes, grocery bills, alcohol, luxury vacations, etc.) through our art work, which makes us so-called "professional" artists. Although we have done residencies and conduct workshops and teach, sometimes for semester-long periods, we are not professors at any university and we are not employed by anyone. We do not write grants. We rarely sell work either through galleries or directly from our studio. (At this writing we are only represented by one gallery: McClain Gallery in Houston.) We currently share a studio and office space in Houston, where we present exhibitions of our work and the work of other artists.

We began collaborating in 1983 while students at the University of Houston. From that time until 1989, we worked various jobs to survive. Jack worked various odd jobs doing carpentry and painting, while Mike was Coordinator of New Music America from 1984 through 1986, and then later was Director of Exhibitions at The Children's Museum of Houston. In 1989, The Art Guys moved into a large warehouse which became The Art Guys World Headquarters. It was then that

The Art Guys
SUITS: The Clothes Make The Man (The Art Guys with Todd Oldham)
Conceptual art/business project
1998–99
Courtesy of the artists and Museum of Fine Arts, Houston
Photography by Mark Seliger

we both quit the jobs we had and dedicated all of our time to our work. Fortunately, for the past 15 years, most of the paying opportunities that have come our way are by invitation. Our list of clients, if they could be thought of that way, consists mainly of museums, universities, university galleries, and various public and civic entities that deal with public art. Occasionally we are approached by individuals for private commissions. Because we do not work in any specific manner or medium, and because we are known for unusual projects, it seems that more opportunities are presented to us than other artists. But this is just a guess.

Running The Art Guys is like running a business with files, computers and phone calls. Almost all of our business is conducted by e-mail which, like everyone else, is completely different than it was 15 years ago.

Beginning around 1995, more and more of our daily activity was devoted to the business of art. This was due to the nature of our work and the necessity of organizing various projects. It was around this time that we began to more seriously integrate business activity with the work itself. Now, they are virtually indistinguishable to us.

The business of art, at least as far as The Art Guys are concerned, has a nuanced and layered portion to it. As an extension of questioning various phenomena of the world and investigating these phenomena in what may be thought of in sculptural terms, The Art Guys have included this business activity as part of the work. An obvious and well-known example of this is our "SUITS" project, wherein we leased advertising space on a pair of men's gray business suits designed by Todd Oldham, and then wore these suits for a year, thus advertising for our clients.

The most recent investigation into the business of art is a piece in which we are literally trying to sell ourselves, by offering our bodies in the form of our cremated remains after we die to a collector who wishes to purchase us. For the first time, a collector may purchase the actual artist, in this case The Art Guys.

As another example of selling ourselves, we went through an expensive and laborious effort to trademark the name of The Art Guys with the United States Trademark and Patent Office,

and now we are trying to sell the very name that we have spent nearly three decades developing as a "brand."

Business, capitalism, branding, marketing and advertising are ingrained in the American culture. As artists, we consider it our duty to investigate, experiment with and question all of this. For many years, we have done so and now we think we're finally getting somewhere.

May we give you our card? •

Thomas Kilpper
From the on-site project, *State of Control*
ca. 205cm x 275cm
Unique lino-print on paper;
State of Control was a floor cut in the former ministry for state security of the GDR (Stasi HQ), Berlin. The section shown here: migrants on their dangerous way over the Mediterranean to Europe via Lampedusa, Italy 2009
Courtesy of the artist and Galerie Nagel Draxler

SHARON LOUDEN (SL): Can you share with me what your practice is like on any given day, balancing your creative practice with the practical aspects of your life?

THOMAS KILPPER (TK): Somehow this is not strictly separated as I am quite chaotic and badly organized. In my "normal" daily life I am very lazy and not disciplined – my art projects mostly are not carried out in my studio but on-site, wherever. I must concentrate all my energy and focus on the process of these weeks and months. As my work deals to a great part with the notion of physical intervention and overspending/exhaustion, it is quite frazzling, but I like this intense process to go to the limits.

SL: What kind of things do you do to sustain your creative practice?

TK: My creative practice is full of interruptions and breaks, and stays somehow in opposition to a sustainable process. First, sparks of possibilities often come during awakening, in the small time slot when I am between unconsciousness and consciousness and still a bit numb... it's my starting point to develop ideas.

SL: Do you have occasions to talk with curators, gallery directors, and others to have exhibitions and the like?

TK: Yes of course; before you have a show you talk about it with curators or the like.

SL: What is that like? Do you enjoy the dialog with them, and is your practice a more collaborative one with curators?

TK: Of course, this depends on the curator and our relationship. Generally speaking, it is a very sensitive relation between the artist and the curator – not always easy, as they have their aims, their agendas and you have yours, and if it does not match to a certain degree, you cannot show together.

SL: Do you have assistants that help you with your work? If so, what kinds of things do they do for you?

TK: I work with assistants on my large-scale projects. They might help build an installation or help with printing, or whatever is needed. It depends on the assistants – what they can or want to do – and it depends on my budget for the project.

SL: Some artists like to work in complete solitude. Do you work in your studio while others are present? Is the nature of your practice collaborative?

TK: Sometimes I work in solitude, sometimes I work with assistants, and sometimes I work collaboratively. The latter to me means a collective process and the result is "ours", not just "mine" – when two or more artists work equally together, and not as assistants but partners.

SL: Can you talk about what kind of hours you keep, or when you work on your own work? Does it involve "business hours" of others who are related to the business aspect of your life as an artist?

TK: As an artist you need to work 25 hours, eight days a week – 25/8 not 24/7.

SL: You have an exhibition space called *After the Butcher* that is open to the public, as well as your own studio in the same "complex." Can you talk about how you manage this space while getting your work done?

TK: I consider my project space as a part of my art practice. It is not meant to develop a commercial gallery business. I believe both practices correlate and interact with each other. But to develop my own art projects clearly is my main emphasis. *After the Butcher* (the project space) comes secondary, although it is not of marginal importance. Mostly, the openings at *After the Butcher* are the highlight of the shows. For Franziska, my wife, and me, inviting the public into my house is very special and a great opportunity. After that, visitors need to contact us prior to visiting the exhibition – though we have two large shop windows.

SL: What do your galleries do for you that you don't do for yourself, and vice versa? What type of things do you have to bring to the galleries that you work with and what sort of things do you have to do on your own?

TK: In the first place, a commercial gallery is important to try to sell your work and to organize some income. The gallery should also mediate contacts to curators or museums for shows in another space. Showing at commercial galleries is a special task for me – it asks for a different balancing between experimental needs and commercial approach.

SL: Directing where you want your work to be seen and specific audiences for your work, how do you determine where your work is shown? What are the choices you make? Are they based on the type of work you're doing in the studio or the venue that you're choosing?

TK: First of all, normally you get invited to a show. Only projects in non-institutional frames – in empty buildings or so – I organize without an invitation. I belong to the type of artists that can hardly say "no" to any invitation. I had to learn to say "no," but when I do not participate I always have a guilty conscience about it.

SL: You haven't been able to enter in the United States for many years. Has that limited your opportunities and income as an artist?

TK: Sure, I would have been a billionaire if I could have come to the States. No, seriously, so far I missed two opportunities: I had an invitation to a printing project within Philagrafika in Philadelphia, and to meet a curator of the printing department of MoMA in New York. Of course it was sad not to get the permission from the US embassy to enter the States. You might see this as a destructive attitude of the "land of the free," but such regulatory behavior won't stop any artist ever; it is outdated and part of symptoms that indicate the States is past its best.

SL: How do you find opportunities to exhibit your work?

TK: Somehow, to me, this is not so much the question. I believe the exhibitors, and even the exhibitions, find you. The exceptions in my development and work are projects at places that have not been art-related sites before my intervention. These projects I have started from scratch on my own – and maybe I'll continue with this very practice even it is very labor-intensive and time-consuming.

　　Generally speaking it applies more to me to ask: How do we find our way to develop interesting and good art? Or even: What makes art "good art?" Where is the place to discuss and exchange reflections on these questions?

SL: Is it important for you to exhibit your work? Some artists just like making the work and release it to the world in different ways.

TK: For my understanding, art is a social process – the exchange of new aesthetics, new ideas, new questions on cultural, social issues. This process is dependent on public reception. Public reception needs public exhibitions. As long as someone is doing creative work just in his or her studio, it's not part of this process and exchange within the society. Once the public gets in touch with it, this process can start. I am very much interested in this very social process and exchange. To separate oneself from the world and withdraw in your studio... to me, and for the kind of work I do is not an option. But, of course, it can happen that an artist works without getting any attention but is able to realize important work for generations after his or her death. But this "Van Gogh-phenomenon" is quite rare. Most artists need the above-mentioned process of exchange, critique, reflections from outsiders...

SL: What is the best venue for your work (i.e. museums, non-profits, self-starter/DIY exhibitions, etc.)?

TK: I am mostly interested in site-related interventions with links to the sociopolitical sphere and its historical layers. I am interested to find out to what extent art is a medium to trigger political and social changes towards emancipation, and social equality and individual diversity at the same time. Almost all venues are interesting with always different options and challenges. If you can develop your work within the frame of a museum, you might have a better budget, a more professional assistance and generally better conditions. To me, the only important things are: what are the ideas behind an exhibition, do these ideas apply to me? And do the working conditions for me as an artist match with the general ones. It does not make sense to get invited to show in an institution where everybody enjoys professional working conditions but the artist. That means, for example, an artist fee is obligatory within a professionally working field and institution.

SL: Does your family have a role in helping the productivity of your work? How do they support what you're doing and/or assist in any aspects of your work in or out of the studio?

TK: Sometimes I ask my partner – so she comments on what I plan and often this is helpful, almost a corrective.

SL: As a follow-up to an earlier question about your exhibition space being an extension of your art practice: did you start *After the Butcher* to create community?

TK: No, it is not to create community but to develop the opportunity of a non-commercial space – more like a laboratory or so. What direction of contemporary art production do we want to see flourish? This is the good thing about Berlin: there is no such thing as the "*Butcher*-community" because Berlin is so big that every exhibition brings new and different visitors. No opening is like any other. This also has to do with the fact that we are interested in very different artists.

SL: Finally, how has your practice of balancing the practical side of living and sustaining your creativity with the making of your art changed over the years? How have you been able to find a balance between making your work and all of the other responsibilities of sustaining your practice?

TK: It is hard to find an answer to that. Maybe my practice has changed very little, maybe too little – and I certainly wish to radically change it and break with some routine habits. •

EVERYTHING IN ITS PLACE AND TIME

Living and sustaining my life as an artist today requires attention to many details, all of which play critical roles and require varying degrees of attention and dedication. Some activities come very naturally and give me enormous amounts of pleasure, while others are tedious and often seem like nothing but a distraction from what I really want to be doing. My ordered mind would tend to diagram every activity with percentages and graphs, but I'll spare you that level of detail and lay out some of the broad strokes of how I negotiate my time.

RELATIONSHIPS/HAVING A LIFE

For me, sustaining a creative life would not be possible, or at least not very interesting, without the support of my partner of over 20 years. Muse, critic, editor, sounding board, and one-man support system, he always encourages me to soldier on, even when I take off for a month or two to recharge at an artist residency program in some remote part of the world. Then, of course, there is the extended network of family and friends who support what I'm doing whether they understand it or not. We spend time together hanging out, preparing meals, hiking in the local mountains, taking in a movie or the occasional concert or performance. Also, a weekly routine of yoga and spinning classes help keep me sane. All these activities taken as

Timothy Nolan
Restack
51"x104"x145"
Laminate, mirrored Plexiglas, aluminum and MDF
2012
Courtesy of the artist and
CB1 Gallery

a whole keep me going, and fortify my art practice in subtle but substantial ways.

RESEARCH

Exploring things that interest me, like natural phenomena, science, music, dance or traveling to new places near and far, all inspire me and feed my creativity. I'm usually not even conscious of the influence such things have on my work or my process until after I finish a piece or body of work. It may not be that obvious to viewers, but I see the influences of these interests in the work and consider my pursuit of them a vital part of my creative life.

SEEKING OUT

This category swings towards the tedious end of the spectrum, but it is a necessary evil: "You've got to be in it to win it." Researching and applying for grants and residencies and responding to RFQs (requests for qualifications) for public art opportunities takes up more time than I'd ever want to admit to, but when it pays off, victory is sweet! And having to write cogently about my work forces me to step back and take stock of what I've been up to in the studio. Even the hours spent polishing up digital images compels me to get some visual distance and a fresh perspective on what I have had my nose in for months on end.

The most important part of all those applications is having the highest quality images possible. For every hour I spend making and installing work, I probably spend three or four photographing, formatting and fixing digital images. While I don't miss the days of getting slides duplicated for every application and portfolio packet, I occasionally wonder what I did with all those free hours before the dawn of Photoshop!

PUBLIC RELATIONS

Keeping my website current, updating people about shows and other news via e-mail blasts and social networking sites, mailing out catalogs and cards, corresponding with galleries, curators, and other artists takes a great deal of my time. This includes working with the galleries that represent me, building relationships, letting them know how hard I'm working and

encouraging them to partner with me. Developing these partnerships takes time and effort, but in the end, it is all part of the business of art. And all this communication is crucial for me getting the work out there and engaging in the overall cultural dialog.

KEEPING CURRENT

I try to go to galleries and museums on a regular basis. I try to attend openings for friends' shows, and I try to keep up with articles, blogs and books that are relevant to my work in one form or another. It's important to stay in touch with what's happening beyond the four walls of my studio. I enjoy being part of a community, especially catching up with friends and colleagues at openings or bumping into them while out at an exhibit. I think it may have been a turning point in my career when I figured out that staying connected to my peers is an indispensable part of tending to my creative life. I make most of my work in isolation, so reaching out and getting feedback or tossing around ideas with artists and arts professionals keeps me plugged in and grounded at the same time.

PROFESSIONAL COMMITMENTS

Over the past few years I have had the pleasure of lecturing and being a visiting artist at some local colleges. I have also been a panelist on a few selection committees: one for a public art project and another for a residency program. And this year I became a member of the Services to Artists Committee of the College Art Association. I enjoy these activities very much. In addition to being tremendous learning experiences, they also reinforce my interest in serving as an active citizen in the arts community. Participating in this community is undoubtedly one of the most sustaining activities of my life as an artist.

SIDE JOB

Selling work is always a thrill, but I have never relied on sales to cover all of my expenses. My side job started as a temporary assignment at a law office 20 years ago, while I was hunting down teaching jobs and running up against limited prospects. Now I am very fortunate because I typically work two days a week, and

my schedule is very flexible, so I can easily juggle hours with studio time, studio visits, exhibition installations, trips to New York, San Francisco, and elsewhere, and even time away at artist residency programs. The work varies, sometimes monotonous and sometimes interesting, but it has nothing to do with art, so it never creeps into the psychic space of my studio. All these years, a regular paycheck, however modest, has afforded me stability so that I can stay focused on my art, and not on how I'm going to pay next month's rent.

STUDIO WORK

Finally! This is where the real work happens. It's the heart of my vocation, my *raison d'être* as it were; I treasure it and I guard it voraciously. I'm almost always wanting for more time in the studio, and I have come to depend on the occasional residency to provide me with blocks of uninterrupted time to clarify direction and get to the next level in my work.

This is not to say that every moment in the studio is sheer bliss. Overall it is very rewarding, but at times it's very challenging. Recently I heard Chuck Close on Charlie Rose saying, "Inspiration is for amateurs, the rest of us just show up and get to work." This really resonates with me because I always have to remind myself, while in the throes of searching for the next body of work or resolution to one problem or another, that showing up and doing the work will get me there. And so it always has. •

Tony Ingrisano
Peruvian Documents 3
48"x44"
Ink and graphite on paper, cut
and rearranged
2012
Courtesy of the artist

I spend time in my studio almost every day, but how much time is highly variable.

I teach a few classes at a small college based in Long Island, and I teach twice a week with an arts education organization that provides supplementary arts curricula to public elementary school students in the city. Teaching is amazing. It's an engaging and fulfilling experience, but the pay isn't great (downright rotten in some places), and doesn't provide enough to live on. I also work for a photo company that does public and private events, and the hours are long but I'm freelance there, so I have some choice in how often I work. I will do enough work there to pay rent and buy food each week, but seldom more, as I tend to choose studio time over excess money.

I finished grad school about four years ago, and since then I've had about a dozen jobs. Most of that work is in art handling and working in other artists' studios, assisting them with their own work, and my experience as an artist assistant has been really invaluable. I've worked for about six different people in all. I have a few friends who work for big name artists that everyone has heard of – the huge production set-ups, and their work is always a combination of dozens of assistants, with completed art going straight to a blue chip gallery (sometimes with the paint still wet). These artists are in such high demand that most of the work is sold before it's begun. By contrast, my

artist employers have always been the opposite; artists who you likely have not heard of, but whose output requires some help to keep things going fast enough. They seldom have budgets that allow them to employ assistants full-time, but they show at reputable galleries and, more importantly, have established a base of collectors who show a consistent interest in their work. Working so closely with these people really gives you an inside view of how they handle things such as finance, production and time management. Most were very cool and didn't mind talking about the business side of things, how they handle their life and career, and some I still consider very good friends.

Being a freelance worker is hard as hell. Most of my peers began working freelance out of school, but almost none do anymore. It presents challenges that wear you down. The allure of having a steady job with a regulated schedule, having reliable paychecks, earning benefits (always the tipping point) – it all adds up to what seems like a no-brainer when compared to freelance work, which is the opposite of all of those things. But it can be done. It just requires tenacity, copious amounts of effort and a little luck. And like everything else, lots of practice.

As for making money through my own practice, I do, and the percentage of my overall budget increases slowly as more people see my work, but it fluctuates dramatically and many months may pass without selling a thing. I have shown with some great galleries, and will continue to do so, but having work up doesn't necessarily translate to selling work, so I take that into account, and keep expectations realistic.

My good friend and I started a small gallery in 2009 in downtown Brooklyn, and we put up about ten really stellar shows over the course of two years. Both he and I had art-handling experience, and we partnered on the logistics and troubleshooting. We sold a decent amount of work for the artists showing with us (we never exhibited our own work there; I fervently believe curating yourself into a show is a dangerous practice) on a miniscule commission, but the community created was our main focus. We lost access to the space a little while back, and that suits us just fine; it was getting to be a lot of work, and we are proud of what we created. If the opportunity presents itself again, we will certainly jump on it, and with more

knowledge and experience. My partner is already being tapped for input by a small gallery in DUMBO.

So, whenever possible, I am in the studio drawing, working through ideas and juggling completing big projects while looking ahead to what's next. I take every minute I can get, and when I need to be at a job, I simply draw before and after and make space for it. I tend to be a bit of a shut-in because of it, and skip a lot of social and personal events and opportunities to keep the production going, which can be hard to deal with. But it works because it's what I choose to do; I prefer it to other things, and if I'm ever out of the studio for long, I start to itch for it. What sacrifices need to be made are just that – things that *need* to be done in order to have time to work on my own. I sleep and eat and breathe drawing, so it's only logical that I'd do anything necessary to keep drawing. •

Will Cotton
Relic
65"x50"
Oil on linen
2007
Courtesy of the artist and
Mary Boone Gallery

SHARON LOUDEN (SL): I'm talking to Will Cotton today at 1:33 p.m. on Monday, June 11th, 2012, in his studio in downtown New York City. Will, I'm just going to bring up the first time I had met you: we were sitting next to each other at a gathering at the Whitney Museum, and it was your birthday, and you were very generous to share with me some of your experience as to how you came to be here. Some of the things I recall you talking about were your, perhaps I wouldn't say struggle, but creative ways of sustaining and making a living enough to make work on your own. Forgive me, but I think I recall that you actually worked in some plumbing or contracting? So can you just talk about those early days and how you came to that?

WILL COTTON (WC): Sure. What happened began out of necessity, like so many things do. I needed to find an affordable loft space to have a kind of live/work situation. And what I was able to find that I could afford was a space that was literally just an empty space. There was a bathroom, but that was it. No walls, no lights, no plumbing, no kitchen. So I went to the bookstore – this is pre-YouTube tutorial – and I bought a Time-Life book on how to renovate an apartment. There was a chapter on electrical, a chapter on plumbing, and a chapter on kitchens, and I just started reading that book and taught myself all those basic skills. Again, out of necessity, because at that time I couldn't afford to hire anyone else to do it for me. So in renovating my own

place and building walls and running electrical and plumbing, I suddenly had this new skill set that I realized was valuable to friends of mine, people I knew, who were also moving into lofts. Some of them actually had the money to hire somebody, so I became that person – that very inexpensive contractor who would do their plumbing and electrical work. And those types of jobs were good for me because it meant that I could work for a solid week and then take two weeks off to paint. I think, for an artist, that's often a really nice thing, as opposed to a constant and regular schedule, when you then have to squeeze in studio time evenings and weekends or whenever you can.

SL: So, the two things that are most resonant to this experience are that you were concentrated on finding a space – so real estate is important – and then the second thing is flexibility. And those two things enabled you to make your work. Is that correct?

WC: That's true, and I'd say the other important thing is a respect for my own studio time. Because given those circumstances, one could just open up the want ads and start looking for a job. I set parameters that I needed these big chunks of time to be in the studio. So the question becomes: How do I get myself in a situation where, in terms of real estate and work I can still make it all happen without diminishing the studio time down to nothing? I think that's the real tough part of that.

SL: So once you had that schedule, how did you wean off of working in contracting to where you are today? And what were those signature moments? Because I think that artists sometimes are concerned of not letting go of a job because they're afraid that if they let that go, they're not going to have that income to sustain them. What was it for you that you were able to just say enough with that?

WC: I'm not sure that I've said that. [Laughter]
I guess there's a part of me that is that pessimistic. It's been a little more than ten years, probably 11 or 12 years, since I've done a contracting job. But you never know. I mean, it's always possible. Knock on wood, or something. It's funny, because I

was showing at galleries during that whole period while I was doing contracting work. I moved to the loft on Broadway that I described – that was '94 – and I started showing with a gallery named Silverstein at that time, and showed with him through '98. 1999 is when I started talking to Mary Boone and wound up starting to work with her. I probably did my last contracting job in 2001 or so. I was showing at Mary Boone and still contracting, which probably a lot of people don't realize either. Just because you're showing, you're not making, necessarily, enough money to pay the bills. And more than that, it's just very up and down. That's the thing all artists have to contend with. You can have a good month, and of course, the first good month I ever had, I thought: that's it – this is going to be it from now on. And two years down the road you realize that's absolutely not the case. There are good months and bad – still. So I think if there's a [fourth] leg of the equation we talked about before – which is the real estate, the job, and having studio time – it would be learning to handle one's budget with the irregular income in mind. Knowing that even if I made a certain amount of money this month, I have to imagine that that might need to last me the next six months.

SL: That's really interesting. So, you still have these skills that will always be a backup security, even though you may not ever fall back to them.

WC: Yeah, that's right.

SL: Now, here today, what are the things or the people in your village that help you continue to sustain your creativity with an ease and flow every day? Who are the people involved that make that happen?

WC: I think there are a few distinctly different and equally important kinds of support people in one's life; certainly in mine. And let's say the first line is people like you see here, like my assistant, Angela. Angela is wonderful – she does all the things that would keep me from being at the easel and making paintings. So she's not in there helping me make paintings; it's kind of the opposite. She does everything else… and there are so many

things. On any given day, I could find plenty to do that would make it so I don't paint. And that's just obviously ridiculous. So she is very skilled in a lot of different areas; everything from bookkeeping, inventory, some photo-processing work, all those things that go along with being an artist, yet keep one from actually making art. Yet another example would be one's artist peers. On Saturday, I had my friend Ryan McGinness come over just to do a life-drawing session. And this is something I've done a lot over the last decade. I'll very often invite a friend or group of friends over to draw from a live model, regardless of what we're working on – any of us – in the studio; just come over, draw a nude girl, art school-style. And those kinds of social and creative interactions are so nourishing, I'd say. In other words, it's important to me in that I can't justify that activity in terms of the general commerce of the art world. For me, and for most of the people that come here, we're generally not selling these drawings, we're not showing these drawings; it's just something that feels important to us to be doing.

SL: Would you say that part of the support you need to sustain is also your community?

WC: Yes, exactly.

SL: Okay, and then in addition to that, as far as working with galleries that you work with – I don't know if it's just Mary Boone – but how do you juggle working with them? I am assuming that keeping that commerce *out* of your studio practice is important to you.

WC: Yeah, it is. And I think it's because I've been doing it for a while, but it also feels pretty easy to me. I learned, probably 20, 25 years ago, that I can't guess what anybody's going to want anyway, in terms of that kind of commerce in the art world. Like, if I thought, okay I've gotta do a show, I've gotta make some money, I'll make a bunch of paintings of skulls and… what's popular right now? Shiny things, maybe. [Laughter]
 That, I learned, just won't work out for me. It won't be fulfilling, and it also probably won't sell. I have never had the experience that that's actually a viable way of working. So my

bottom line here, my rule of thumb, is to always make sure that I'm excited and engaged on a daily basis by my own work. So if I go into the studio and I'm starting a painting and I'm feeling bored, I really force myself to look into why that is and change something so that stops.

SL: A big thing for me in this book is to show that each artist has a different way of sustaining and making a living for themselves, to sustain their creativity. A lot of graduate students leave and say, I'm going to just get a gallery and they're going to take care of me for the rest of my life.

WC: Yeah. [Laughter]

SL: That's an expectation that's out there. Would you say that that's realistic? And if it's not, could you explain how that role of the gallery helps you; how it is a part of your life and how much so?

WC: I guess you'd have to say, off the bat, of course it's not realistic. If you look at the numbers – people coming out of grad school, and potential slots at galleries… it's easy to just do the math and see that that's an unrealistic expectation. That said, I don't think it's a bad thing, psychologically, to believe in that possibility. I think I was particularly naïve coming out of art school, too. Maybe also with appropriately low expectations though. Some of the first shows I did were in a friend's barn upstate; I just invited a bunch of people over. I also showed on a wall in a bar here in New York. These were some early experiences with making $500, making $2000, money that started to feel like, oh, well there *is* potential. Commerce is possible, but always augmented with something else. I should also say, at the same time, that conceiving of a so-called fallback plan didn't really work out for me either. I thought at one point, when I was having a particularly hard time, I'll just get some illustration work, because I have some rendering skills and I've always known in the back of my mind that at least illustration is a fallback. I made a real effort to get even *one* illustrating job, and I got nothing. I got nothing at all. So all that time when I'd been thinking, well, I've got this fallback plan, it was an absolutely

worthless plan. I guess it turned out that in developing those contracting skills and seeing that there is a use for that, it became a kind of fallback, or at least a "round out the necessary income" kind of thing.

SL: Many artists want to know how to navigate that terrain of working with a gallery. How do you do that? For example, do you talk to your dealer every day? Do you have Angela speak on your behalf? How do you navigate that relationship and then keep it out of your creative process?

WC: I think having regular contact with your dealer is really important. I personally speak to Mary myself once a week. That feels right to me. I'd say to anyone who thinks that signing up with a reputable art dealer means the work is over, that's not true. That is not true at all. [Laughter] It's so important to maintain that relationship, but in addition to that, one needs to develop relationships with curators, collectors, critics…. Dealers will do their best, but there's a lot that they actually can't do. It means so much to critics, curators, and collectors – all of them – to know the artists and to have some kind of personal, if not relationship, at least personal knowledge of that person, as opposed to just the work. And that's ongoing. All the other artists I look at seem to do the same thing, and some much more than me. There are artists I know who spend a good part of their day every day on developing those relationships. That's not me; I haven't been able to structure my schedule like that, but I can see the value in it. It does come down to relationships, for sure.

SL: And it seems like you love to give back. I know of a lot of artists in this book that extend their creativity beyond just making their work by also volunteering out in the community. How would you say you do that, and what inspires you to do that? And also, how do you fit that in your schedule? What's the role for you in your creativity to do things outside of your practice?

WC: I'd say that the biggest, most common way for me that I do that is to be a visiting artist at various art schools, including the New York Academy of Art. Because, in general, the pay is either

nothing or not very much, so it's not like that's a motivating factor. But I have found it to be very rewarding to go and talk to art students. Selfishly, because it makes me talk about the things I've been thinking about, and it makes me put them into words. If I address a class of grad students or do a round of studio visits, I have to find the words to explain myself, and that process, like the process of life drawing regularly, just keeps my mind sharper than it would be otherwise. You could say, in that sense, my somewhat benevolent work is quite self-motivated at the same time. I just realize that this is beneficial to me to do, and so I do it. But not in the sense that I'm being paid a lot, so it feels a little bit more charitable.

SL: Can you talk about the role of failure in your life as an artist? Would you say that failure is something that pushes you in other aspects of your life too?

WC: I should say failure is, to me, more of an abstract fear concept than it is an actual entity. I also feel like it's almost impossible for me to gauge success or failure. It's a subjective judgment at its core. For example, for the last show that I just had at Mary Boone, I made a big sculpture. I still don't know how to judge the success or failure of that sculpture. Maybe I'll never be able to. Making sculpture is such a foreign thing to me, and it's probably because of that – I just don't feel like I have anything to balance it against. However, I *do* form that judgment; if I do, in the end it's not going to be because it sold or didn't sell, or because some critic liked it or ignored it; it's a bigger thing than that. More than that, it's kind of an unknowable thing. So when I say failure, I'm really speaking more to the fear of going outside of the norm.

SL: To conclude, it sounds like all of these things that you've spoken about, and these people in your community and what you go for to challenge yourself, seem to be those keys that enable you to live and sustain your creative life. Would you agree?

WC: I would. I think to say just that, though, is to undervalue the alone time in the studio, which is also huge. Maybe it's stating the obvious, but I feel like it needs to be said – my relationship with my own work and my engagement with my work is most important. If I think back to the first impulse I had to make art, it was when I was young – I'd see a Tiepolo painting and I'd want to go and make one, end of story. What I've learned over the years is when I get excited by something like that, the trick for me is to find myself within it. •

CONCLUSION

Ed Winkleman and Bill Carroll

SHARON LOUDEN (SL): I'm here with Ed Winkleman and Bill Carroll in Ed's gallery in Chelsea on July 17th, 2012, to record a conclusion to this book, *Living and Sustaining a Creative Life: essays by 40 working artists*. One of the reasons why I asked them to sit and talk with me today is because they both have had many years of experience working with artists and seeing how artists have evolved. Bill Carroll is a "senior" gallerist, if you will, even though he's not in that role at the moment. In addition to being a fantastic artist in his own right, he serves as the Director of the studio program at the Elizabeth Foundation (EFA); is that correct, Bill?

BILL CARROLL (BC): Yes.

SL: And then we have Ed Winkleman, gallerist, as well as activist through his blog. He has also written an extremely informative book detailing how to build a gallery, entitled, *How to Start and Run a Commercial Gallery*. One of the reasons I asked both of them to contribute to the book is to hear about their experiences in the art world over the years. I wanted to get their views on whether it really matters if an artist is represented by a gallery, or whether one's "pedigree" is important to achieving respect as an artist living and sustaining a creative life. Can you talk about that, Ed?

ED WINKLEMAN (EW): I suppose that's, like, maybe a couple of questions, so maybe we could break it down…

SL: How about if I say this: a lot of artists I have met, especially young artists, feel that when they get out of school they have to have a gallery in order to be considered "worthy" as a professional artist. I'm more interested in asking the question: What defines an artist publicly? Many of the artists contributing to this book talk about the simple sustaining power of just making their work every day in their studio, and that's enough to call themselves artists. It's not a public process. And yet they must sustain outside of their studio, as well. Could you talk about that dynamic, perhaps?

EW: I think whether or not you have a gallery is a question a lot of people who identify as an artist are asked almost immediately. And within the population of people who kind of understand how the art world works, it is seen as a milestone. Seen as a potential career goal. But I also find that there *are* younger artists using the model of building an art career completely independent of a commercial art gallery system, and it is equally viable. I think it doesn't get as much attention because there aren't consistent advertising or promotional pushes for those artists. As opposed to a gallery artist who gets more exposure through the promotion of a gallery. So you might get a sense that Artist X, who shows with this gallery in New York, this one in London, and this one in Los Angeles, is having a good career. But truth of the matter is Artist X might not be making anywhere near as much money as Artist Y, who doesn't have any galleries. But Artist Y isn't having the ads bought for individual shows, or isn't necessarily having their work shown at art fairs or these other sort of more public places. So it's a more under-the-radar sort of career to have if you don't have a commercial art gallery. I think that confuses a lot of younger artists into thinking that they must have a commercial art gallery to meet their goals. Because how else would they measure it?

Now when I talk a little bit about how to get a gallery in some of my lectures, I start off with the idea that there's a spectrum

of places that you can exhibit your work: everywhere from a restaurant to a museum, non-profit places in between, etc. The commercial galleries have been one choice in that spectrum. What I ask artists who are interested in getting a gallery to really think about is whether getting a gallery helps them meet their goals. Oddly enough, that usually triggers them to say they're not sure what their goals are. So then I say, okay, that's really where you have to start. What are your goals? Is it that you want to have, you know, a museum retrospective by the time you're 50? Is it that you want to be able to live off of your art? I mean, what are very concrete goals you have? And believe it or not a lot of times a commercial gallery can be completely irrelevant to those goals. Figuring out whether or not your goals require you to have a commercial gallery is extremely important and something we talk about.

That said, it's a little difficult for me, being a commercial gallerist, to really delve deeply into what all of the options outside the commercial gallery system are. I mean, I'm really focused on what we're doing here. But I know a number of artists have very, very successful careers outside the commercial gallery system. Some of the artists that we work with, for example, we sell some of their work, but nowhere near as much as they show in museums or biennials or other things, and you know, a commercial gallery for them is a nice little extra off the side. It doesn't even come close to making them the sort of money they get from these other opportunities to exhibit their work.

SL: Bill, what do you think?

BC: I think, when I talk to one of my students at Pratt in professional practice, what we really talk about, first of all, is entering the dialog. The first thing most artists want is to be in their studio making their work, and that's what they're dedicated to. And if you just want to do that and then hope it's discovered after you're dead, that's one route. But, with the artists that I'm meeting, first of all, they've come to New York to really enter into the dialog. For me, the question is: Do you need to have a commercial gallery to enter into that dialog? And in fact,

no, you don't. There are people, as you were talking about, Ed, those couple of artists that you represent, whose bigger part of their career is actually in museums. I remember one artist in particular, when I was at Elizabeth Harris, that we worked with. At one point we were doing a lot of site-specific installations in our smaller space. This was a big focus of mine with this artist. But very much on a one-shot deal because they were unsalable. At another point, we took on one artist who did these big site-specific installations, which were really not very saleable. But the fact of the matter is she was at that point already a mid-career artist. She had had other galleries at different points, but the main part of her career was in museums, especially university museums. There were a lot of places out there that couldn't wait to have her come and do a big installation; places that did not care whether they were going to be sold. That wasn't their primary goal. Because one way or another, no matter how you slice it, galleries are a business, and at some point it becomes about salability.

There are a number of artists who do these site-specific kinds of installations or performances, and can also figure out a saleable part of it. I always think Ann Hamilton's a great example, who did these amazing things. All the little video things she did were equally good – and were saleable. There are not a lot of people doing the installation stuff who can manage that. That said, I've met a number of artists who have their careers either doing the museum thing, where there's a big audience for that, or are doing other sorts of projects – especially some of these younger artists who are doing all kinds of guerilla-type art situations, where they're bringing their own friends, that sort of scene.

There are lots of ways to be in the dialog without being in the commercial gallery system. But I think, ultimately, that's the first decision: is this art-making thing something you're going to do just for yourself, and you're not worried about showing at all? I don't think that is the case with anyone who's going to read this book. Finally, in terms of making money, I've also met a lot of artists who have plugged into art consultants around the country, and who are selling work on a regular basis. Sometimes they are making a lot of money and don't have a commercial

gallery, although they do have some other kind of commercial outlet.

SL: So would it be fair to say that you consider somebody who's a professional artist just somebody who's simply creating? Or, is the importance to engage in the dialog paramount?

EW: Well, those are two different things. Somebody who's simply creating can sort of participate in the dialog, but you obviously can't engage in the dialog without creating. For instance, we're just starting to work with an artist who has a 30-page resume of exhibitions and had her very first gallery show at age 60, and did not need a commercial gallery whatsoever to have the success she's achieved. She's in MoMA, she's in the Whitney, she's in the Biennial, she's in all the history books. She's major. She defines a big section of the dialog. She didn't need a gallery; it was just nice to have after she met a lot of other goals for herself. So, yeah, it's completely possible outside the gallery. Sometimes it's probably even easier.

SL: Well, it's interesting to hear that. I think part of this book is that a lot of these artists do talk about the different road maps that they take to be able to sustain their creativity and living in order to keep going as artists. So, based on what you just mentioned about this artist and her 30 years, can you talk about some of the other artists that you've worked with that they have sustained their creativity and livings as artists?

EW: Well, I can elaborate on the one I just mentioned. In addition to teaching, she got virtually every grant known to man. And, again, got it through the strength of her work. To be really honest though, at a certain point the decision to work with a commercial gallery came because she realized that there were no grants that she hadn't gotten, and it was very unlikely she would continue to get as many as she had because she'd already gotten them all. So that can be one of the factors that can drive somebody into a commercial gallery.

BC: I always say to my students that, in the same way that you're in your studio coming up with a very individual body of work, that's really your voice and not like anybody else's – your career should be the same way. It's important to compare and contrast paths, of course, but that no two careers look exactly the same. For instance, certainly teaching's a big part of it. Also, some of the artists at the EFA are graphic designers, and they do it freelance and they get paid a lot of money by the hour.

Two more things artists need to remember: (1) keep your expenses low right from the beginning. I've watched a lot of artists, for instance, in the late 1980s, when there was a boom and they really overextended themselves, and then when the crash came they were really not in a good situation. It's important that even when things are good, you must keep your expenses low… it's a really good thing. (2) If you're going to have a day job, try to keep it somehow connected to the art community. I think that for you to spend hours of a day doing something that's so completely disconnected… even if you're working part-time like up at the EFA, you're meeting other artists; there's a kind of networking that goes on that I think is really important.

I was going to say, I was also thinking of artists who have found other ways to make a living. One artist that I worked with back when I was at Charlie Cowles was an artist who made big sculptures. And in the early 1990s when the crash – that crash, it was two crashes ago now –when that happened – boom. The gallery part of it; we stopped selling completely. He ended up going into public art. So he started applying for all these public art commissions and ended up getting them. Once he had one really big success – he did something in Boston that was a huge success – that really became his career. He now basically does public art. And as far as I know, I don't even think he has a gallery or has had one for years. But that's like almost another world he got plugged into, where he's highly respected; he does these amazing commissions, he knows how to do them, he does them on time, everybody loves them. There are so many different ways you can find as an outlet for your art.

SL: What do you think the expectations are now for an artist, versus, let's say, 20 years ago? Are they the same after leaving school? Do all newly-minted art school grads expect to get a

gallery immediately? Is being part of a community important? That sort of thing?

EW: I think you have to go back more than 20 years. When I go back 20 years, I think it's very similar. It was sort of after the Neo-Expressionists and everybody was just making tons and tons of money. I think the expectation, to get really historical about it, started at more or less the same time that Warhol started to take off. You could be both a rock star and an artist at the same time, and whether or not it was really realistic, that started to become the dream anyway. I think once that became the dream, that trickled down into art schools. Everybody coming out assumed... I mean, not everybody – I guess there was still a generation of students being taught, "these galleries are your enemy; you will never make any money." Some of them bought into it, but the smarter ones were looking at the other people making money and thinking, "well, you're saying that but look at them over there." So 20 years ago I think we were well into the era when artists assumed that they could have a successful career living off their art. And I would say at least that segment of the artist population dominated who was approaching the galleries. At that point, artists approaching the galleries were assuming that they were going to be able to live off of selling their art. So it really hasn't changed that much.

SL: Do you think, though, that there's an expectation now versus before? The expectation being that it will automatically happen?

EW: Well, I think there are more galleries than ever before; the market's a lot larger, that's for sure. So yeah, the expectation is in place because of that. But, honestly, I go back to the artists that lost their galleries in the early 1990s, and those are folks who were out of school 20 years ago now. All of the East Village crowd – they all assumed they were going to be the next big rock star. This is why they moved to New York; this is why they were going to the East Village. What Bill said is really important, though: a lot of them thought the money was never going to end. And the market *did* crash, and they were completely unprepared. I think in terms of preparing artists to have a lengthy career and make

money, somebody has to show them that this will always go up and down. There will never be a constant rise in the market. I mean, really great artists, who should have known better, got wiped out at this last downturn.

SL: In 2008.

EW: Which is ridiculous. I mean, they were so unprepared for it to come back down again. It's just shocking to me that they didn't see that that was a very strong possibility. So I think that's a big deal to emphasize.

SL: Bill?

BC: Well, as you said, to go back historically, which is a really long way, but when I was in art school the model was [Willem] de Kooning, who had his first one-person show at 40. You didn't think about showing the first ten years out of school. And it took a long time to actually have work that was mature enough that you would dare put it out there in that dialog. And obviously that changed, and I do think the big change was the boom in the late 1980s, which to me was pretty much the exact same as this last boom. There was this boom, and everybody took it for granted. Everybody was making tons of money, every show we had was selling out, and people took it for granted. And then, boom, it's over. And yes, it's really important for artists to realize that. And that's something I really emphasize when I'm talking to young artists: you need to be able to get through the tough times. Just because you're selling a bunch of stuff right now…. It's a very fragile world! It's the first thing people cut out when there's a recession [buying art]. You need to be ready when that happens. I have a number of artists at the Elizabeth Foundation; I can think of one artist in particular, who had a gallery and part of her income besides teaching was at least $50,000 a year from her art. And it just stopped completely. Suddenly she doesn't have $50,000 that she had before, because when this crash happened, people stopped selling. It was a done deal.

So you have to be in it for the long haul. I do think that during the moments of boom, whichever one you talk about, the young

artists expected immediate gallery representation when they graduated. I talked to someone up in Columbia University recently who told me that it was a real problem; that it had gotten to the point where everybody who left Columbia immediately walked into some big gallery career. One of the problems with that is that the few who didn't get immediate representation thought that they were failures, a year out of graduate school. They thought that their career was already over. I thought those were *really* unrealistic expectations.

I think in that way the downturns are a good thing. This last one was like a light switched off from one year to the next. When Lehman Brothers declared bankruptcy, the lights went off. It was like overnight it was a completely different story. And in ways, I think that's a good thing; the kids who came out in the middle of this difficulty and, in a way right now, are getting a much more realistic sense of what it's like to be an artist, where it's hard to sell. You know, it's not guaranteed. I'm sure right now the kids coming out of graduate school are dealing with very different mindsets.

SL: And yet, what you were talking about earlier about perception is important – how some people on the outside (collectors or curators, for instance) see an artist with a lot of gallery shows and think that he or she is doing just fine. What about this possible misperception that seems to never go away?

EW: That you seem to be more viable if you have a network....

SL: Right. One reason why I've edited this book is that I want to show that an artist can have that validity without that perception. I think that's harder for the artist in a lot of ways, though. Would you say that that perception is the same, if not more, than years ago? Or less so? And also, who are the people contributing to this? Is it just the collectors?

EW: I would say that an important factor in this is that purchasing has sped up incredibly. People are making buying decisions so much faster than ever before, and I think that goes

hand in hand with the collectors we know wanting the security of the gallery behind this artist or that artist. The idea is if a year from now they realize, oh shit, that was a mistake (buying that artist's work), the gallery will take that work back. Because, you know, they're afraid… especially if there's a hot artist; they're afraid if they don't buy it right away it won't be there at that price point, and blah blah blah. But they definitely want to know they're not going to be stuck with this work if, in a year from now, they realize they were wrong. So I hear this time and again: that collectors feel more comfortable buying work from an artist who has a gallery because there's that institution behind that work. And I think that really contributes to how quickly it's selling. They're not really necessarily buying with their eyes; they're buying with their ears. And the more you buy with your ears, the more you want those other people (i.e. the gallery) behind the work for you.

BC: It's true – the idea that that gallery is showing some artist does immediately give them some kind of validity. There's definitely a perception that, oh my god, they're showing at that gallery, they must be making lots of money! That might not be the case though. For instance, Leo Castelli showed Cy Twombly for years, and he didn't sell anything. He was selling the Warhols and he was selling the Jasper Johns, but Twombly did not sell. It's like nobody got Cy Twombly at first except Castelli, and he gave him all these shows. So the fact that, oh my god, he's selling with Leo Castelli, he must be selling a lot of work – he was definitely not selling a lot of work. But just to be showing with Leo Castelli was certainly *the* stamp of approval as far as a gallery goes.

If you get your work in MoMA – wow, that's a big thing. Collectors are going to love that, for sure. But then you're suddenly showing with Winkleman Gallery; that is a stamp of approval by Ed, who obviously has a really great eye. It doesn't have to be the only validity, but you can't discount it either, especially since the galleries are putting money into promoting your show, they're doing ads. So, that again really brings you right into the dialog; that the gallery's doing all this extra work.

Even if you have a gallery, though, you really need to be taking care of your own career and keeping your mailing list up. You know, you can't totally count on the galleries, especially if it's a smaller gallery. On the other hand, if you don't have a gallery, you have to be doing all that work yourself, so that if you want a career, in whatever way, you know, guerrilla exhibitions or exhibitions in museums, you do need to be keeping your mailing list up, making sure people know about it. If you really want people to know what you're doing, and you don't have a gallery doing it for you, then you need to be doing it on your own.

SL: Well, it's interesting because in virtually all of the essays in the book, you'll see that these artists do a tremendous amount on their own, with or without a dealer. Nowadays, it seems that it is more of a partnership versus perhaps 30 years ago when artists were more dependent. It was a different system, I think.

EW: There was more of an expectation that the dealer/artist relationship would be for the long run. And you're right, that has changed from both sides. Dealers are grumbling that artists are disloyal; artists are grumbling that dealers are disloyal. I see artists reminiscing about the days of Castelli Gallery. I recently saw somebody put up a photo of Castelli and his stable and all the artists were like, "Oh wow, remember the days, they were like his children..." And to be honest, I think that that is a very dangerous myth as well: that somehow a gallery is an artist's parent. I don't know of any contemporary dealer who feels that they're the parent of their artists, and I don't think an artist should want that. I think an artist should want to be an equal player in their career, making adult decisions with the gallery. There should not be this infantilization of the artist. I think that the expectation, "All I have to do is get a gallery and that horrible stuff is going to be taking care of for me," is (1) a myth, and (2) it sets up disappointment when an artist gets a gallery and the gallery reminds the artist, "I have 15 other artists. I can't take your phone call at three o'clock in the morning."

SL: That goes back to what I was saying earlier, before we started this conversation. I think that this book shows that artists are self-sustaining. And that has been consistent over many centuries, long before this market ever happened. In some ways, it's still the same. And yet, I definitely believe that expectations are different, based on external things like the market, like the pressure for someone to enter in the art world. On one hand, you guys are saying it's not necessary to have a gallery, but on the other hand you say, well, collectors might want the gallery because then they have that stamp of approval. So it's this delicate balance.

It's also clear from reading the amazing essays in the book that the concept of balance is pre-eminent in the lives of these artists. Balance in the sense of being able to continue to create while paying the bills. How do you balance that time, if someone has a regular day job of one sort or another, or another artist has gallery representation and his/her "day job" consists of working with the gallery? Or spending many hours teaching or dealing with paperwork for public art projects, or whatever it is, and *then* making their work. Would you agree that there are many options for an artist to sustain their living while simultaneously developing their creative life?

EW: I would say much more so than ever, and the Internet is a big part of why. A huge part of the marketing can now be done by the artist very easily, from a computer in their studio.

SL: That's great.

EW: And one of the models that we haven't highlighted, but I think you're going to see more and more, are artists like Banksy or whoever, who make a splash, get their own press, their prices go through the roof, and maybe galleries come after the fact. Jason Munson is another really good example. You know, huge galleries are chasing after him after he made his own name via YouTube. So you're going to see a lot more artists doing their own promotion and building their own careers. And then, yeah, they can have their pick of the galleries.

SL: Do you want to add anything, Bill?

BC: Actually, those are good examples of people who found a different way to enter this dialog and make a big splash. In the late 1980s, before the crash, there were 150 galleries in SoHo. In Chelsea, before the crash, there were 300 galleries. So right there, from one main area to the next, it had *doubled* in size. Not mentioning all the other areas where there were galleries, because at one point there were the Williamsburg galleries, now there's the Lower East Side. And there were so many more. When you talk about the days of Leo Castelli with anyone you know from that time, they will tell you that the art world was tiny. An artist would get with Leo Castelli and stay with him for life.

It's just a whole different system now. Things are much more fluid than before, and I do think it's healthier. Because sometimes the artists change, and the galleries change, and the idea that you're going to be with a gallery forever… things are moving too fast now. You know, it's just a different world. But the opportunities are stupendous with the Internet as a tool, and there are so many galleries worldwide. The markets in Asia now… there are so many people getting involved. That is huge. There are just a lot of opportunities worldwide if young artists can figure out how to take advantage of them.

SL: So, we're going to close out this conversation. I know it's a difficult question, but what do you think is the key, or keys, for an artist today to sustain a creative life? To sustain their living? You both spoke about various ways to achieve this, such as self-promotion, working in partnership with galleries, creating diverse exhibition opportunities by thinking outside of the box, developing a public art career. From your experience working with artists over the years, are there any key points that have stuck out and contributed to success in sustaining a creative life for the long haul? Bill?

BC: I think a sense of humor really helps. [Laughter]

SL: A sense of humor!

BC: And by that I mean a sense of perspective. I think that artists who come into this with a very specific idea of what's supposed to happen, that "I'm just going to be miserable if this, this and this doesn't happen," are setting themselves up for disappointment. And these are the people I meet who are middle-aged and bitter. The artists who sustain… first of all, obviously, the first thing is that you're in your studio, you're really connecting to your work, you're making good work, and that is the first and most important thing. From there I do think you need to have a good attitude as you move through the art world. And you've got to be flexible, you know; you put the energy out there but you're kind of flexible to the things that happen. You never know what's going to happen. For instance, suddenly all the older artists around you are having the biggest part of their careers now, in their sixties. In our building, we have Suzan Frecon, who's just doing incredibly. She had a very respectable career, but now she's having this huge career. Judith Bernstein, who's come to speak to my class, who was a tough feminist artist, the first show at A.I.R. Gallery involved in all of that feminist work that really worked against her for many years. She didn't have a one-person show for 24 years. Now Haunch of Venison is buying up all of her early work; the Whitney's buying up her work. And the thing about Judith – I met her before all of this stuff was hot – she really has a great sense of humor. Even though she had been locked out of the system because her work is so feminist, she wasn't bitter about it. Judith really had a sense of perspective. She always taught; she found ways to sustain her practice. She just really had a great attitude, and it's really gratifying to see some of these people rewarded. You know, now they're selling all this work. Even all her early work is being bought up.

SL: What do you think, Ed?

EW: I think Judith is a good example of what I think is just somebody who, despite ups and downs, was more interested in being in her studio and making her work than anything else. I would turn this around a little bit actually, just because it's an easy example – I'll use myself. Nobody knows this, but a long time ago I was an enthusiastic painter. After coming to New York

and spending a lot of time in other artists' studios, I realized I actually enjoyed talking to other artists about their work more than I enjoyed making my own. That was an indication to me that being a painter wasn't what I should be doing.

If there's any part of all of this process that you're not into, or that you're more excited about, like, the parties or whatever, rather than being in your studio, you might want to figure out a different career within the art world. Because being in your studio should be its own reward. And if it's not, then you might want to reconsider what your goals are. If it is, you're going to be happy no matter what happens to you.

SL: So it sounds like anything that would sustain that creative practice is of utmost importance. Always stay within yourself as an artist. Continue to develop your visual vocabulary.

EW: Well, an artist is defined as somebody who's making art, so that's first and foremost what you have to be doing your entire career: making art. And it's really interesting, because you're going to constantly re-evaluate your goals completely as your career progresses. It can start off with huge dreams of being the next Damien Hirst, but alongside of that should always be a much more intimate goal of making that next piece that you're really excited about. That being its own reward.

SL: I love that you said that! Thank you very much!

ACKNOWLEDGMENTS

This book would have never happened without the generosity of the artists who have unselfishly contributed to this labor of love. My heartfelt gratitude and deepest respect go out to each and every one of them; my affection for them is endless.

Jonathan Kalb was my warrior, as he gave me the education and direction to undertake this project. He also assisted in editing the preface, which was invaluable.

And a big thank you goes out to Rachel Nackman for transcribing the three interviews. Rachel was my cheerleader throughout this process.

Many thanks to all of the photographers who generously contributed images of the artists' works that were selected for this book.

Finally, I would like to thank Vinson Valega, for assisting with all aspects of this book. I could not have done this without his extraordinary, continuous support.